BRIDGWATER
& AROUND

THROUGH TIME
David C. Bown

AMBERLEY PUBLISHING

Front Cover: The bridge and quay, 1909. The low tide reveals that a boat is positioned on the gridiron ready for repair work by Carver's boatyard. A mass of mud and reeds covers that area of the bank today. The last building on West Quay directly above the bridge was Binford House. The library building stands there today. Ships and small boats lay on the river along West Quay, but there are none there today.

Back Cover: The Bristol Arms Hotel in 1908, now a branch of Barclays Bank.

First published 2013

Amberley Publishing
The Hill, Stroud
Gloucestershire, GL5 4EP
www.amberley-books.com

Copyright © David C. Bown, 2013

The right of David C. Bown to be
identified as the Author of this work
has been asserted in accordance with the
Copyrights, Designs and Patents Act 1988.

ISBN 978 1 4456 1613 1 (PRINT)
ISBN 978 1 4456 1628 5 (EBOOK)

British Library Cataloguing in Publication Data.
A catalogue record for this book is available from
the British Library.

Typeset in 9.5pt on 12pt Celeste.
Typesetting by Amberley Publishing.
Printed in the UK.

Contents

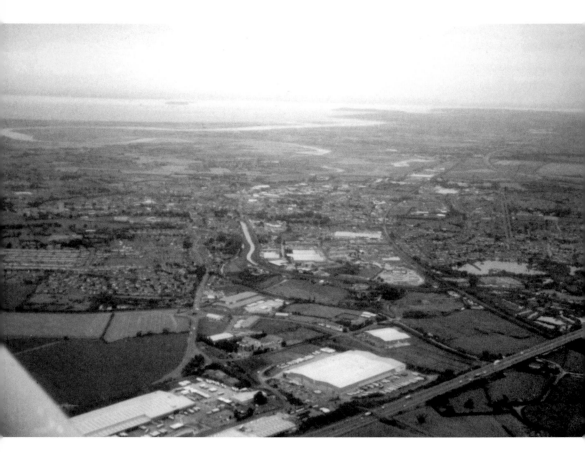

Aerial Picture of Bridgwater from the South-East
This aerial picture, taken August 2000, looks out over Bridgwater from the south-east. At the bottom middle is the M5 motorway. Passing underneath it, from left to right, starting just to the right of the white buildings, is the Bridgwater & Taunton Canal, then the Bristol to Taunton railway, and finally the River Parrett. At the top the river can also be seen winding its way in from the sea at Burnham. The M5 can be seen again at top right after swinging back west around the edge of the town and then heading north again. The road approaching the town at bottom left is the A38 from Taunton. The brown and green fields at bottom left are now the site of a huge housing development called Stockmoor Village.

Introduction

It is difficult to imagine that when some of the earliest photographs in this book were taken the only means of transport for the average person around the town was probably a horse and cart, or a bicycle. Indeed some of the larger hotels and inns, such as the Royal Clarence Hotel in the High Street, had become 'coaching inns', places where horse and coaches stopped *en route* to a variety of places. The oldest picture in this book, from 1879, shows the Lynton stage waiting outside the Clarence Hotel.

The motor car did not appear on the streets of the town until around 1903. Consequently, most of the earliest pictures show empty roads or just a few bicycles, horse-drawn carts or carriages. People walked more around the town in those early days as well because shopping for essentials involved visiting the baker, the butcher, the fruit and vegetable shop, and numerous other shops in order to get everything that was needed. Today we take it for granted that we can buy everything in one visit to one of the many supermarkets around the outskirts of the town. The town was well supplied with pubs or inns. Nearly every old picture of the town, if closely scrutinised, will probably show an inn or two somewhere in the view.

The river was, for many years, the primary source of revenue for the town. Besides the many ships that tied up on the west or East Quays to load or offload their cargoes, ships also had access to the docks, and the warehousing and distribution resources located there. Brick and tile manufacture was taking place at various sites along the banks of the River Parrett using the river mud. Cone-shaped drying kilns sprung up as a result of the need to bake these products at high temperatures until cured, and these kilns appear in many of the old pictures. Boatbuilding and repairs were being carried out at various points along the riverside. Carver's boatyard was on the East Quay

not far from the Town Bridge. The last boat made and launched into the river from there was the *Irene* in 1907.

The broad-gauge railway reached Bridgwater in 1841; a branch line was extended to the east side of the river, and then in 1871 taken across the river, via the telescopic black bridge, and along to the dockside itself. The telescopic bridge was steam powered and one half retracted to allow ships to pass the last few hundred yards upriver to the Town Bridge and quays. In 1892 Bridgwater North station was built and a branch line constructed to Bawdrip, Cossington and beyond to join up with the Glastonbury to Burnham line at Edington Junction near Burtle.

In 1973 the M5 motorway was opened and this passed by to the east of the town. When this opened the impact on the town was immediate. The summertime queues of holiday traffic that used to clog up the town's roads were now a thing of the past. Travel to the West Country no longer included Bridgwater as an enforced itinerary. The town finally reclaimed its narrow streets and its quiet riverside setting.

Today, the cycle has come full circle as the sheer numbers of cars that now exist are once again clogging up the roads of the town. Even the motorway itself, mostly in the summer months, often comes to a complete standstill near the town.

Around Bridgwater, the villages have undergone varying degrees of change. Those villages near to or with easy access to the motorway have changed most, with the others remaining relatively unchanged. As always the motor car seems to be the one common theme when you look at what has caused the changes over the years.

The majority of the images in this book came from old postcards. The dates shown in the text are the year when the postcard was posted, the original photographs probably having been taken some years previously. There are many interesting letters on the back of some of these, written by and in the manner of the people of those times. Sometimes just a short note like 'Arrived safely, will be back on Friday' and sometimes long notes revealing fascinating facts about life in those times. Occasionally old photographs have survived, either individually or from albums. Unfortunately many will never see the light of day, so we are indeed fortunate to be able to use some of them in this book.

Bridgwater

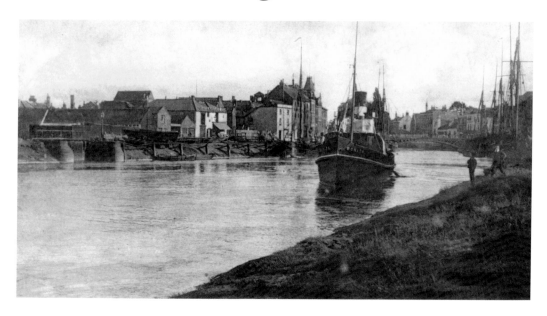

The River, 1903

The steam tug *Bonita* heads downstream on a fairly high tide. The two curved concrete structures with lock gates on the left bank mark the entrance to Carver's boatyard and dry dock. Carver's dock and boatyard are not there today; the land is now occupied by the redundant East Quay medical centre, the large building behind trees at left. Behind that are the bus station and the car park for ASDA supermarket.

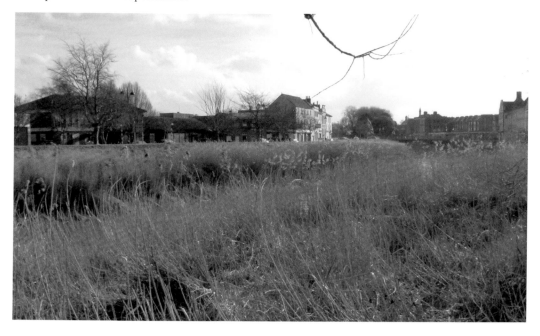

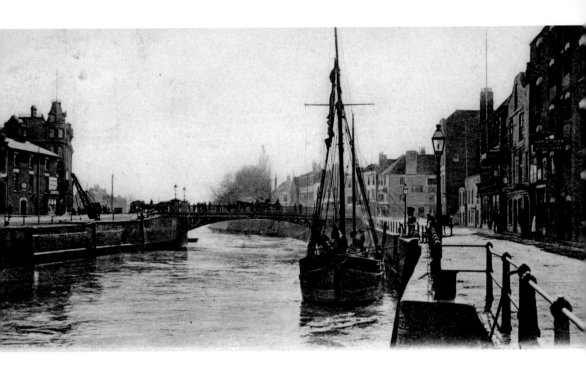

River Parret and Bridge, 1904

A vessel is tied up on West Quay right next to a sign marking the location of the Kings Arms pub. Another sign nearby says 'Hay Straw and Chaff sold here'. The distinctive building of the Kings Arms is still there today, although no longer operating as a pub. On the other side of the river the turreted YMCA building has long since gone, now a 1970s-style building housing a flower shop on the ground floor.

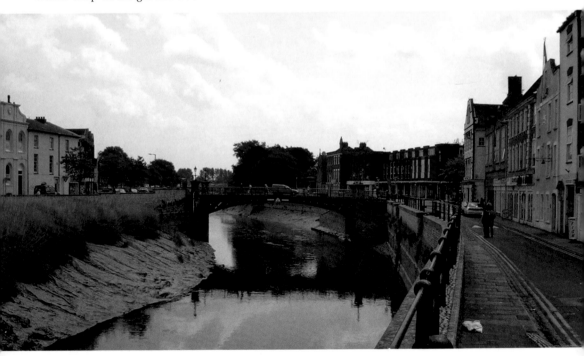

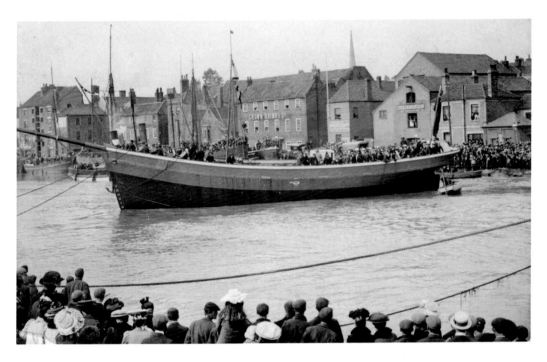

The Launching of the *Irene*, 1907

The *Irene* slips backwards into the river towards the west bank where the buildings of Alfred Peace and the Crown Drinks Co. building were located. In the view today the Alfred Peace building, third from right, is a block of flats, and the Crown Drinks building site is now a car park in front of the West Quay business centre. The most striking thing about the two pictures though is just how much wider the river was along here in 1907.

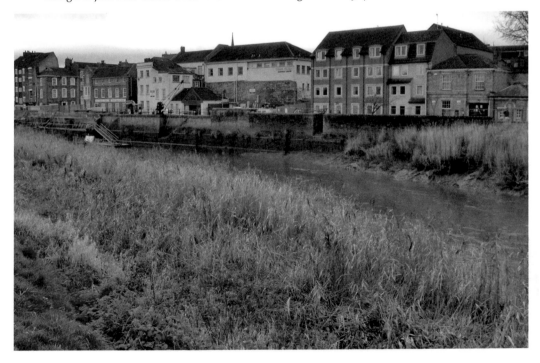

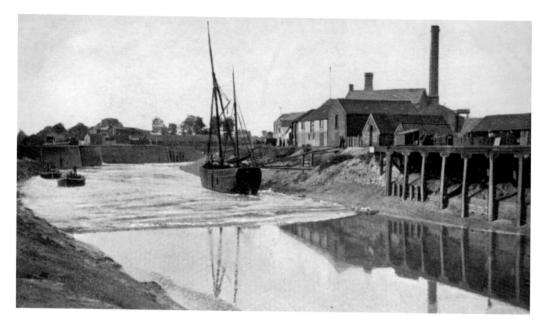

The Bore on the River, 1907

Looking towards the entrance to the docks, the bore is heading upriver towards the Town Bridge. A boat believed to be the *Fanny Jane* is moored on the east bank next to Barham's brickyard. Several Parrett barges near the docks entrance on the left have just ridden the waves of the bore as it passed them heading upstream. Today only a handful of rickety timbers of the wharf survive where Barham's buildings stood.

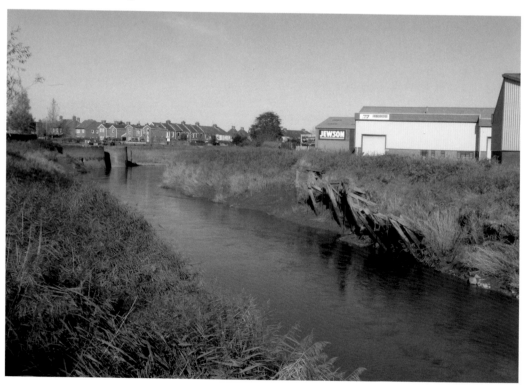

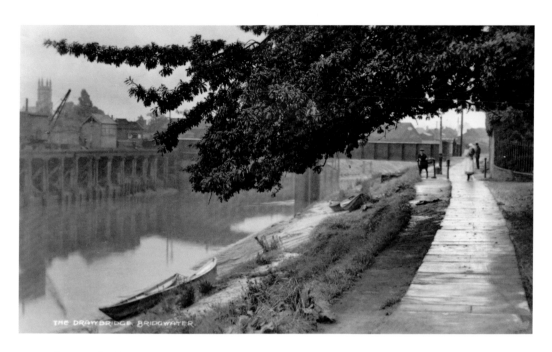

The Drawbridge, *c.* 1920

A wet towpath runs along the west side of the river towards the old telescopic railway bridge. From 1871 the railway crossed the river to the docks via the bridge. The tower of St John's church is visible in both pictures, but the bridge is now only just visible beyond the thick undergrowth on the riverbank. You can just glimpse the path on the extreme right-hand side, still there today, and still a popular route through to the town centre.

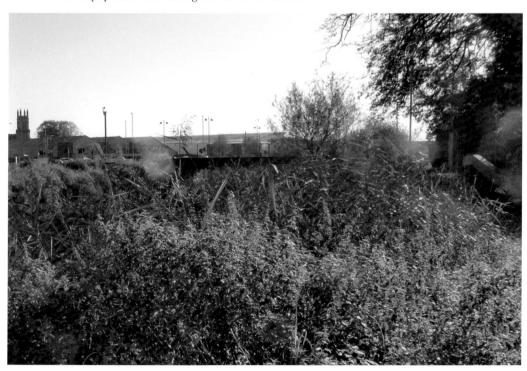

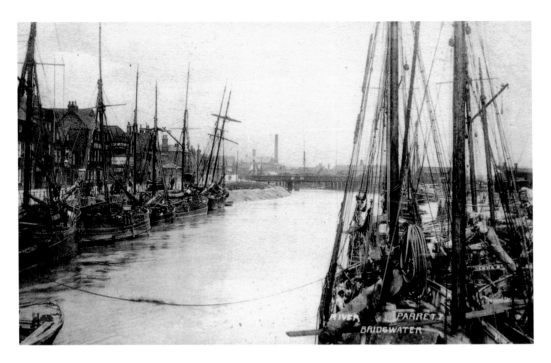

River Parrett Looking North, c. 1905
Sailing ships line the quays on each side of the river, with the black telescopic railway bridge in the distance. On the left-hand side can be seen the buildings of Alfred Peace & Co. Beyond the railway bridge is a chimney from Barham's brickyard. There are no ships today and the black bridge is obscured by the modern bridge where the clink road crosses the river. The West Quay wall is being rebuilt after collapsing in 2011.

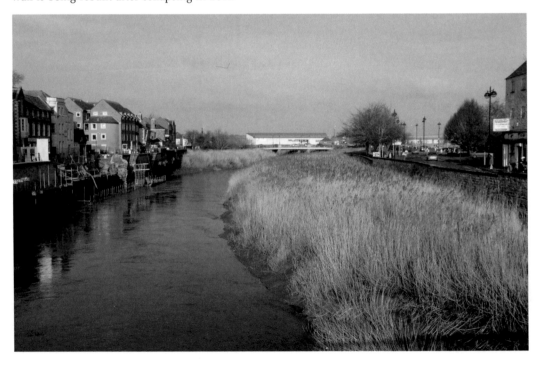

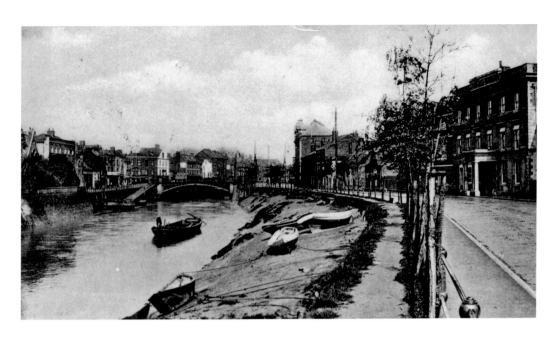

River Parrett, South of the Bridge, 1906

The old towpath runs inside the railings towards the Town Bridge past the Bridgwater Infirmary on the right. The roads are empty. Today the river is much narrower due to the overgrown bank, and a brick wall along the riverbank replaces the old railings seen in the old picture of 1906, built to stop the flooding that used to occur in that area by the hospital buildings.

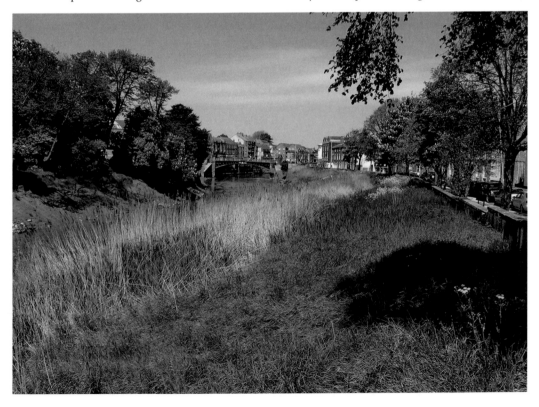

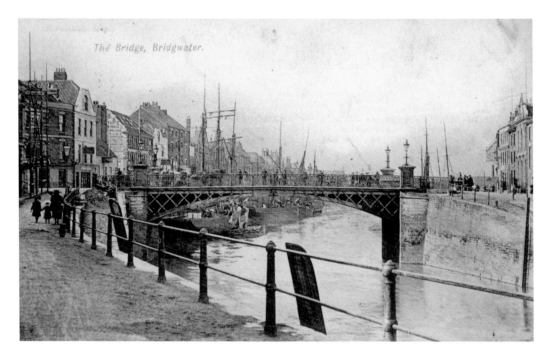

The Bridge, Bridgwater.

The Bridge from Binford Place, 1909

Looking from Binford Place near the library on the west side of the river, three or four ships can be seen under the arch of the bridge moored up at West Quay. The railings along the riverside have been replaced by a brick wall built to combat flooding. The same style of lamps has been retained on the four stone pillars of the bridge and the view is much the same today.

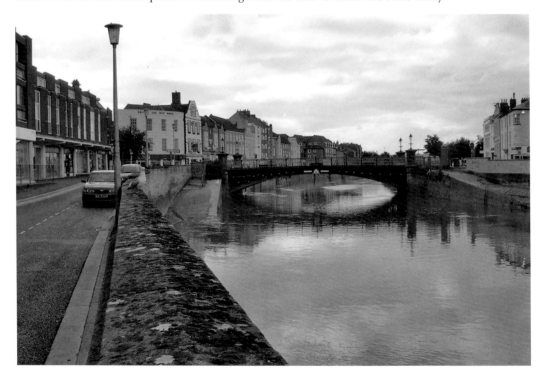

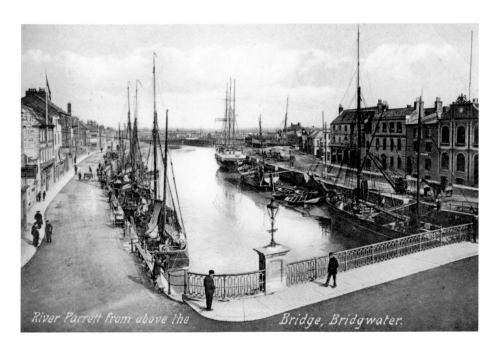

River Parrett from above the Bridge, Bridgwater.

The River and East Quay, *c.* 1905

A view across the bridge looking north towards the telescopic railway bridge. A large boat, which might be the *Irene* under construction, is visible in Carver's boatyard, dating this card to pre-1907. Wilkinson & Leng, builders' merchant's, is one of the large buildings on the East Quay to the right. The boats have long since disappeared and the east bank has built up into a mud bank covered in reeds, severely reducing the width of the river here.

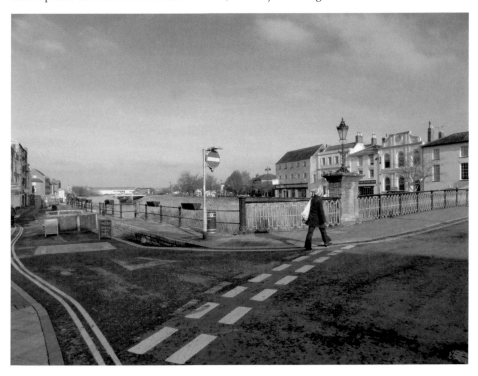

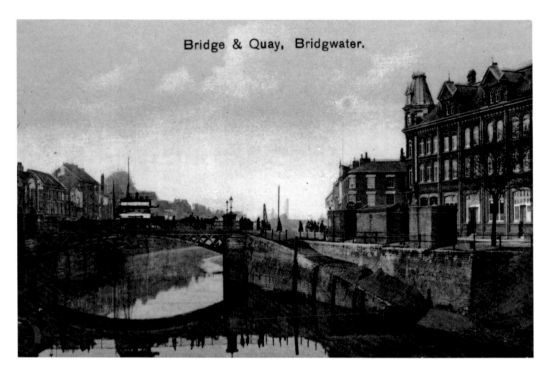

Bridge & Quay, Bridgwater.

The Bridge and Salmon Parade, c. 1920
An early double-decker motor bus trundles across the bridge, following a horse and carriage heading for Eastover and probably beyond to the station. The slipway along Salmon Parade was badly silted up suggesting that river traffic was in decline by the 1920s. The large, turreted YMCA building on the right has long since gone, the three brick buildings next to the slipway are missing, and a car passes over the bridge today.

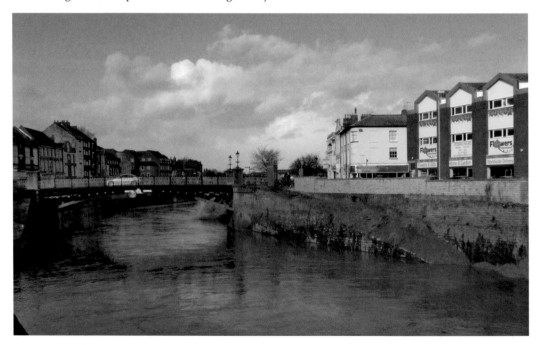

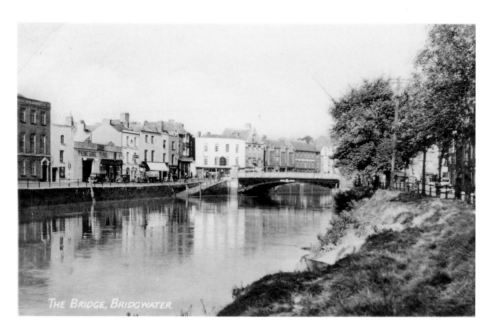

The Bridge and Binford Place, *c.* 1935

McKenna's Garage on Binford Place on the left has two old cars parked outside, and the Dolphin Hotel next door has a lorry offloading beer kegs. On the corner is the Fore Street Clothing Co. Ltd, now the Nationwide Building Society. Today the scene along that road is quite different, with a high brick wall replacing the railings along the riverside. Modern flats and the Argos building, which is now empty, replace the garage and pub.

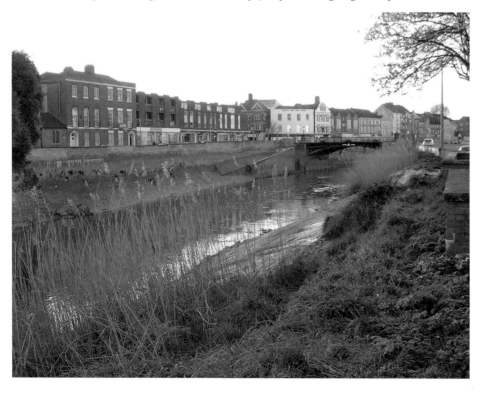

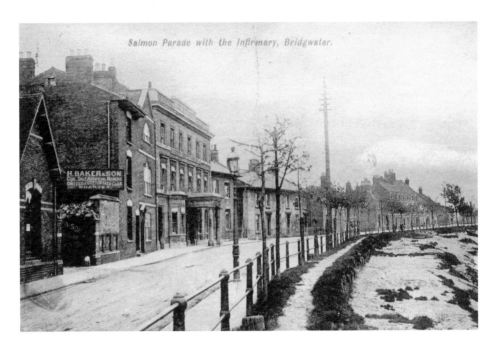

The Infirmary and Salmon Parade, *c.* 1905

The infirmary, or Bridgwater Hospital as it is now known, took over the present building in 1820. The hospital now includes H. Baker & Son's coal yard and the buildings on either side of its entrance. In 1958 the high houses in the distance, on the corner of Barclay Street and Cranleigh Road, were demolished to make way for the new Broadway Road and Blake Bridge. Today the railings along the riverside have given way to a brick wall in the modern photograph.

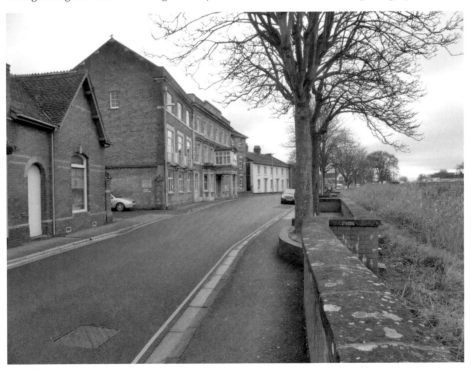

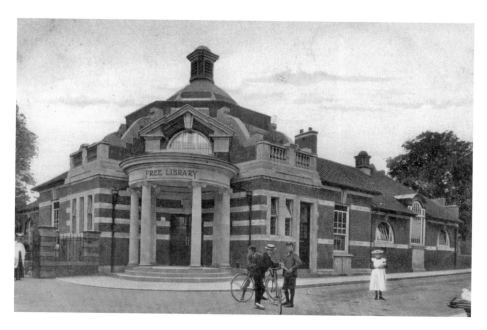

The Free Library, 1913

A lovely colour picture of the library entrance at the corner of Binford Place and Chapel Street, with two boys and their bikes in the foreground, and a young girl in white dress nearby. The library was opened in 1906 and the gates at the left gave access to the riverside walk through the gardens. Today the view is much the same, although trees now obscure some of the view.

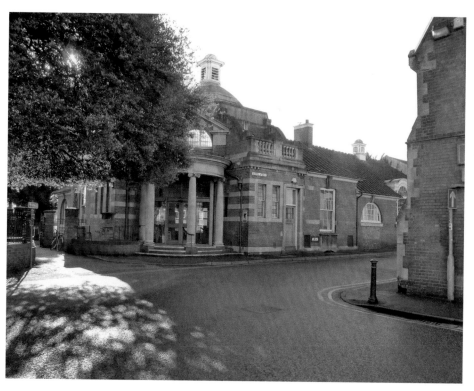

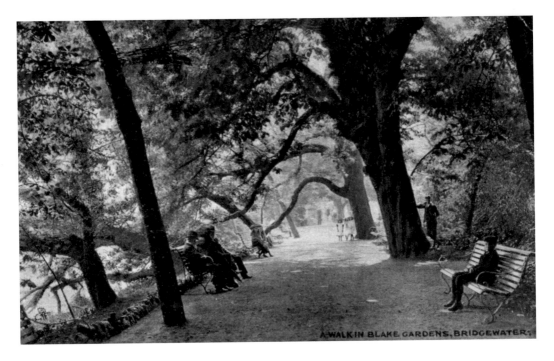

A WALK IN BLAKE GARDENS, BRIDGEWATER.

A Walk in Blake Gardens, 1905

The Chestnut Avenue, or the Avenue as it was known, is a path through Blake Gardens along the edge of the River Parrett, which is to the left. The rows of seats on either side of the path are no longer there. Several trees still hang out over the river at a precarious angle. Townsfolk and visitors alike still enjoy the walk along the river and through the gardens.

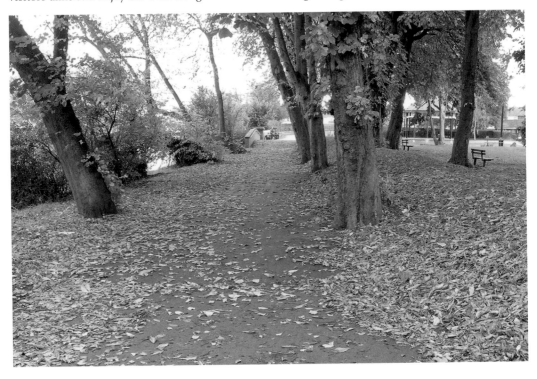

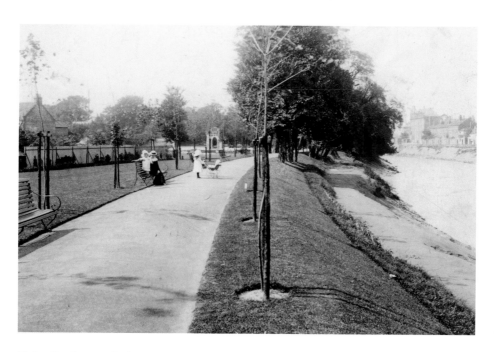

Blake Gardens and River Parrett, 1908

Beyond the immaculately tended lawn and gardens can be seen the turreted YMCA building on the other side of the river. On the extreme left is the last house in St Saviour's Avenue. The archway in the gardens was believed to be from the north transept of St Mary's church. Today only the steps remain where the arch stood, the bandstand has been relocated and the YMCA building is gone. The path descends to an underpass which goes under the main road.

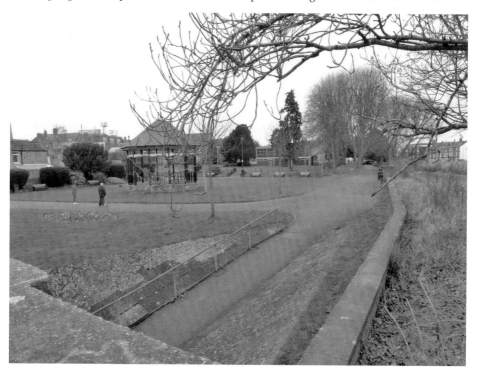

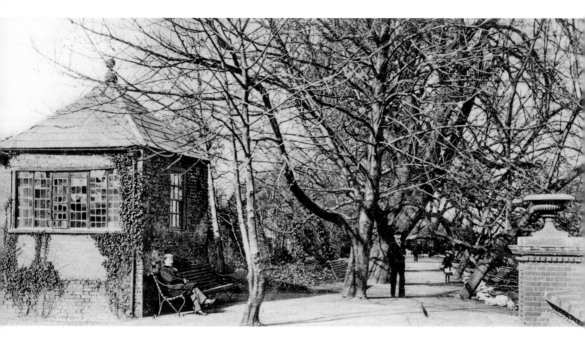

Blake Gardens, the Gazebo, 1904
This dilapidated brick building was the gazebo. The pathway through the trees led to Blake Place, and eventually on to the Town Bridge. There is no trace today of the gazebo and the rather ornate flower containers are no longer atop the brick pillars.

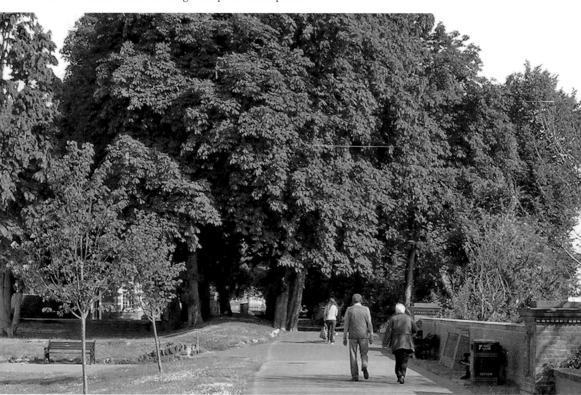

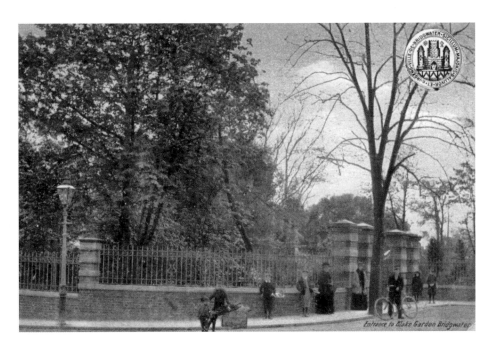

Entrance to Blake Gardens, 1906

The gardens, previously belonging to Binford House, were purchased in 1898 by the Bridgwater Corporation. The library building was opened in 1906. Nine people, including children, pose for the cameraman by the gates. The library building now has several extensions at the back where the trees were, and a large tree overhangs the gates, but the view is essentially the same today.

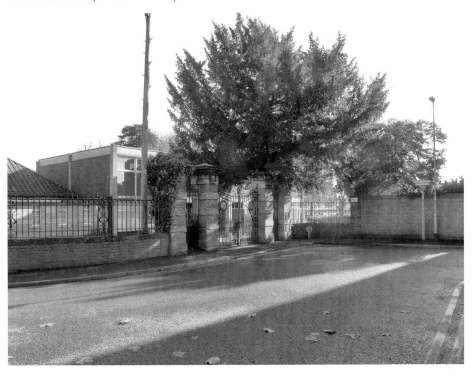

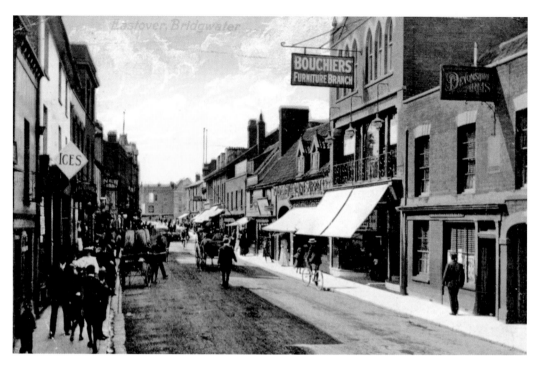

Eastover Looking West, 1908

The Devonshire Arms and Bouchiers Furniture branch are on the right-hand side as we look towards the Town Bridge. On the left-hand side is the New Inn. The buildings on the right look quite different today. All the pedestrians, carts and bikes of old are replaced today by parked cars and traffic.

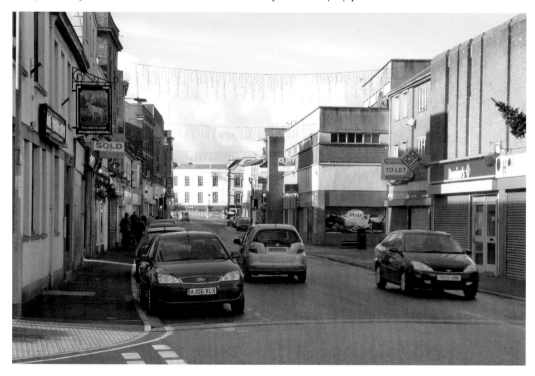

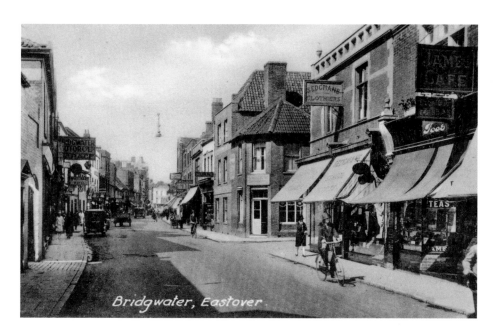

Bridgwater, Eastover

Eastover, Church Street Junction, 1930
Almost opposite the junction is the Bridgwater Motor Co. garage. This supplied the first cars to go on the roads of Bridgwater from around 1903, but the business is not there today. The White Hart Hotel just beyond it is still there. On the opposite side there was James Café, Sedgmans Clothiers, and Mills shop. By 1930 there was a mixture of cars, horse and carts, cyclists and pedestrians on the street. The quiet street view today reflects how shop business has moved away from Eastover over the years.

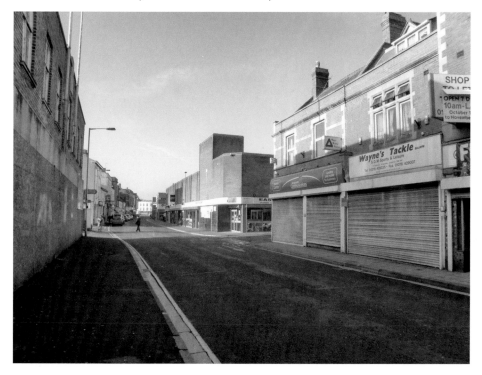

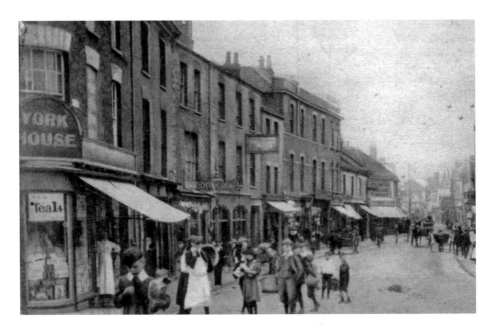

Eastover, North Side, 1908

A lovely early coloured view looking east from the Town Bridge. York House, on the left, has a sign saying 'Tea 1/-4', and further along is Waddon & Son, the Ship Aground Inn, and the Bridgwater Furnishing Company. Some buildings look similar today; others have changed dramatically, and all are now occupied by other businesses. The view today looks rather deserted compared to the busy street of 1908.

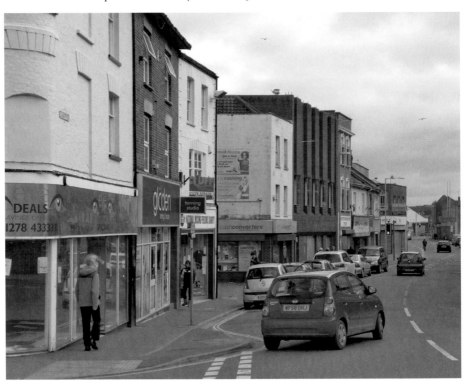

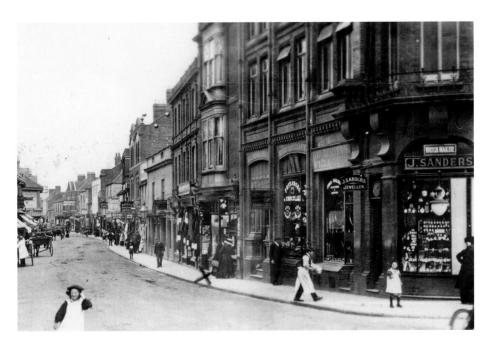

Eastover, South Side, 1919

J. Sanders' jeweller and watchmaker is the first business on the right, then Waddons Cycle Depot, Hutchings Eastover Dairy, Daveys Depot, Ives Stores, P. Brown, the New Inn, and finally the Bridgwater Motor Co. A whole new set of shops and businesses are there today. Apart from the cars the street scene looks rather quiet today.

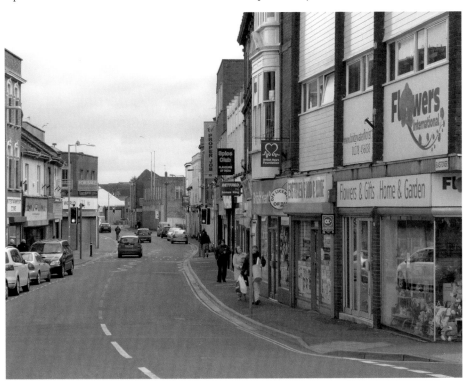

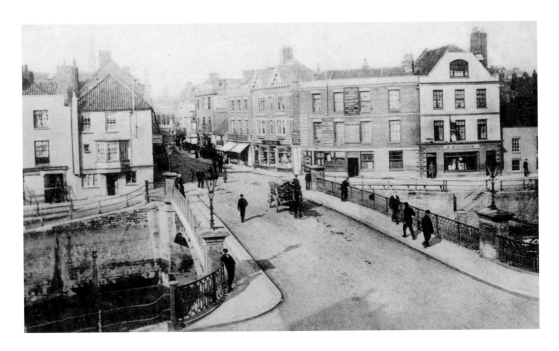

Bridge and Fore Street from Salmon Parade, *c.* **1910**
A four-wheeled wagon with one horse can be seen coming across the bridge towards Eastover.
On the left was the Castle Inn; across the road on West Quay were the Punch Bowl Inn and the
Fountain Inn. The Castle Inn is now the Nationwide Building Society and the buildings look
quite different today. The Fountain Inn is still there but the Punch Bowl Inn, which closed in
1964, is now a branch of the Britannia Building Society.

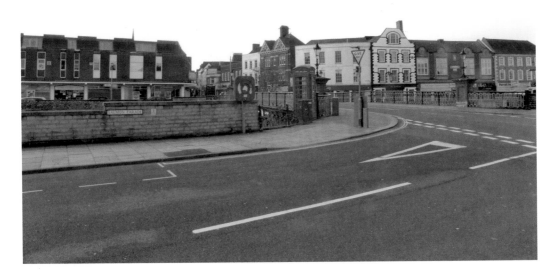

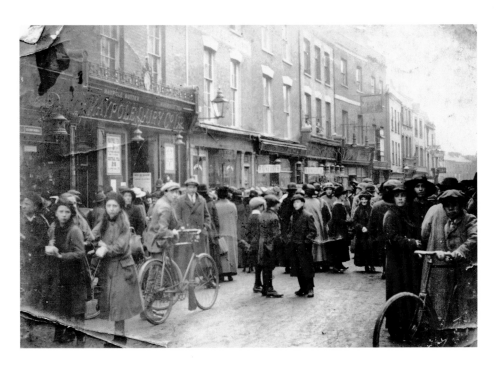

A Margarine Queue in Fore Street, *c.* 1914–18

A note on the back of this old photograph tells us that this was a margarine queue. The shop in the foreground is Maypole Dairy Co. Ltd. Maypole quickly became a household word in the country for dairy produce. By 1924 Maypole came under the ownership of the Home & Colonial Stores, which had a shop further up the street. Boots the chemist, a few doors down, is still there today, but most of the others have changed ownership.

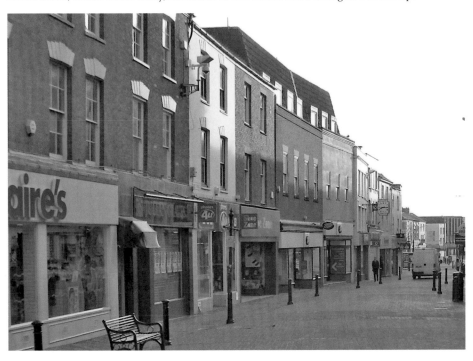

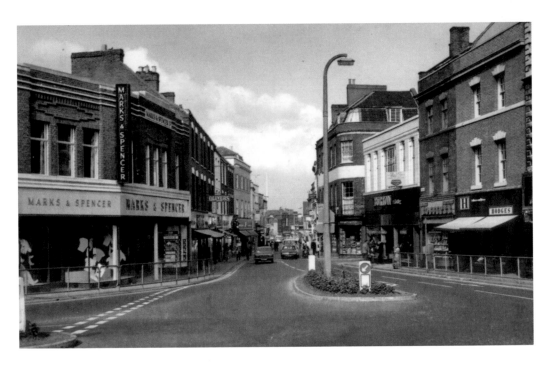

Upper Fore Street from Cornhill, 1960

A colour photograph showing Marks & Spencer on the left, then Oliver's. On the right are Hodges, then Rossiters, Burton, and WHSmith. Numerous cars are negotiating their way up and down the narrow Fore Street, which was still the main thoroughfare through the town to Minehead. Robert Blake's statue now blocks the way, and the road has now become a pedestrian area.

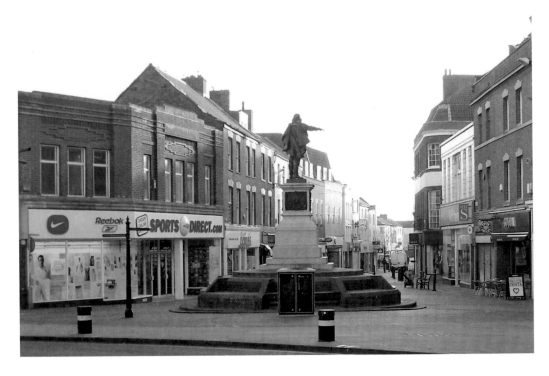

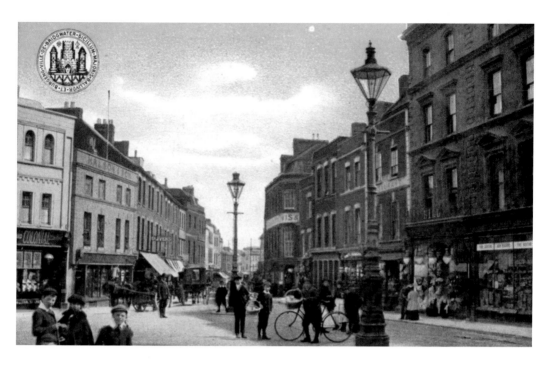

Fore Street, South Side, 1915

Home & Colonial, Halson & Son, and Olivers are the businesses on the left. The Halson & Son building later became Marks & Spencer's, Be Wise and then SportsDirect. Oliver's shoe shop survived on Fore Street for a very long time. Blake's statue now takes prime position in the modern view.

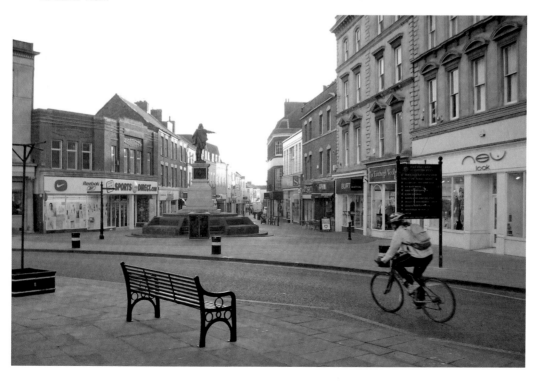

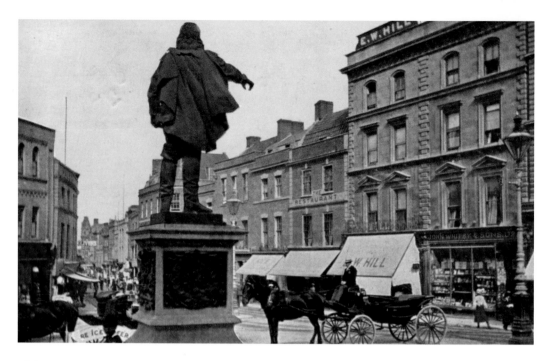

Blake's Statue and Fore Street, 1918

Blake's statue, which was next to the Market House buildings, is in the foreground in this view from the Cornhill looking down Fore Street. In the centre is a horse and carriage waiting for customers. To the right are The Restaurant, E. W. Hill, and John Whitby & Sons Ltd. The buildings are much the same today, just with different owners and signage, and Blake's statue has moved across the road to Fore Street.

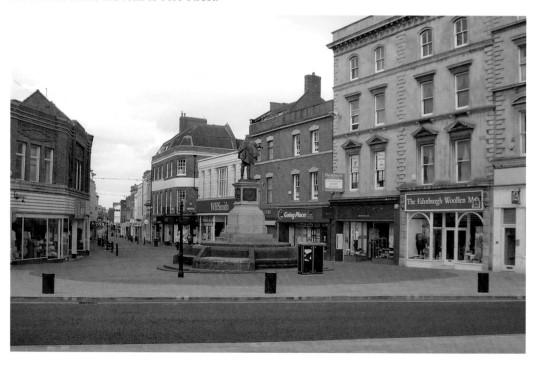

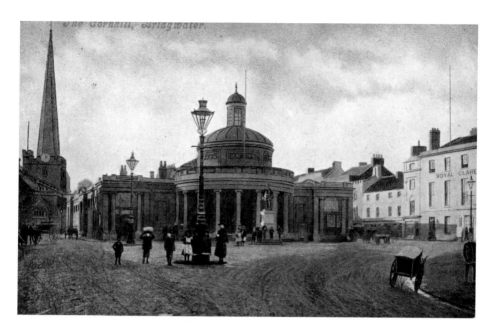

The Cornhill, 1905

Although posted in 1905, this looks like a very early view with the road looking like a mud surface. There is the Royal Clarence Hotel on the right, a few horse and carts in the street and a woman with some children looking towards the photographer. To the left St Mary's church with its magnificent spire comes into view. Today the statue and gas lamp are no longer there, but a bright red telephone box now catches the eye.

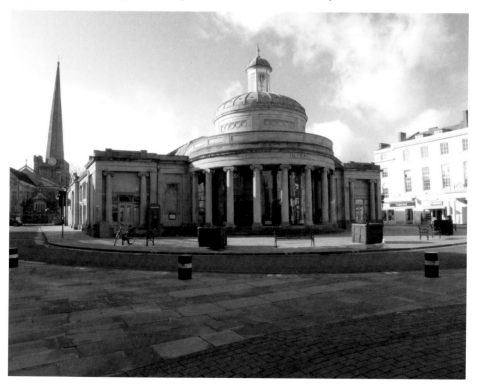

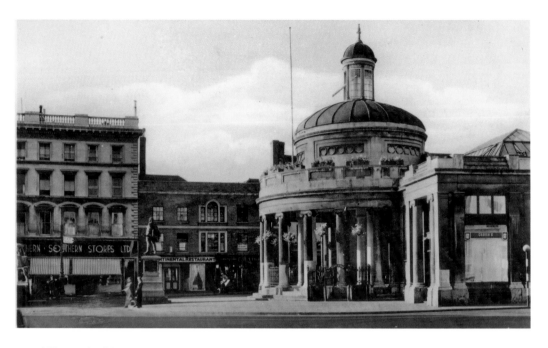

Cornhill, South Side, *c.* 1940
A rare view showing the shops on the south side. Southern Stores Ltd is now New Look, and the Continental Restaurant is now No. 6, the Cornhill pub. The Blake statue has now been moved across the road to the left to the pedestrian section in Fore Street. The only sign of modern times is a car making its way around the one-way system past the Cornhill buildings.

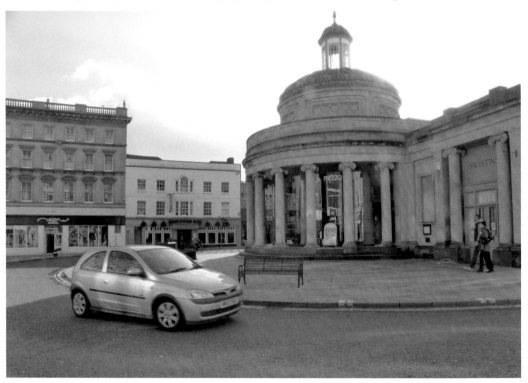

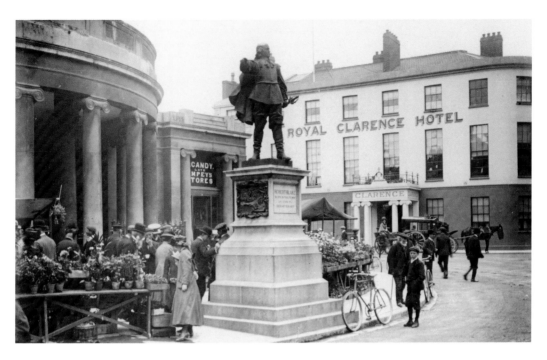

Blake Statue and the Clarence Hotel, 1908

A busy market scene on the Cornhill around the Market House buildings. Candy's Impey stores and the Royal Clarence Hotel are visible in the background. Robert Blake's statue is foremost in the picture; the inscription says, 'Born in this town 1598, died at sea 1657.' The Clarence Hotel is now split into Thornton's, Gregg's, and Specsaver's. The sweetshop is still there today.

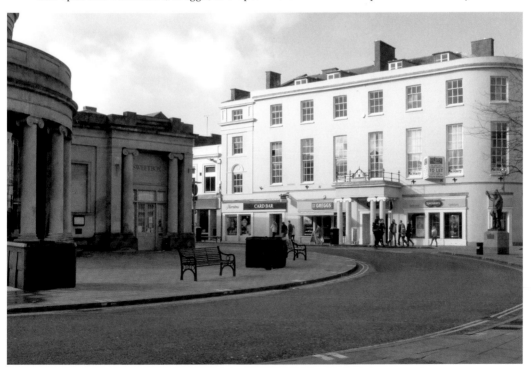

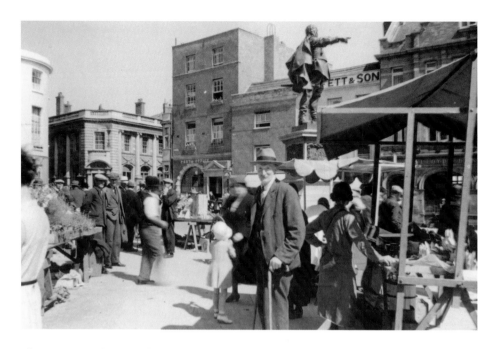

The Street Market and the Post Office, *c.* 1930
A rare view looking from Cornhill towards the post office building, with a busy market scene in the foreground. The Lloyds bank building is visible through the stalls and is still there today. The Buffett & Son building to the right of it was, until a few years ago, part of the post office building but that was relocated to a shop in Angel Place, then the Splash site. NatWest bank is still there on the corner next to the Clarence Hotel.

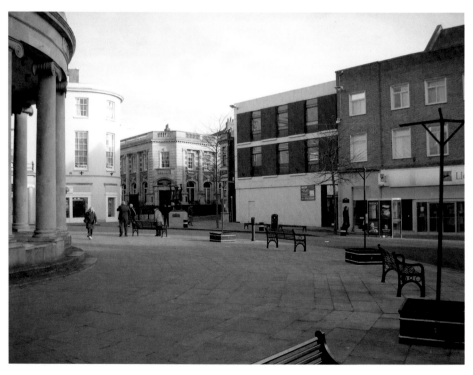

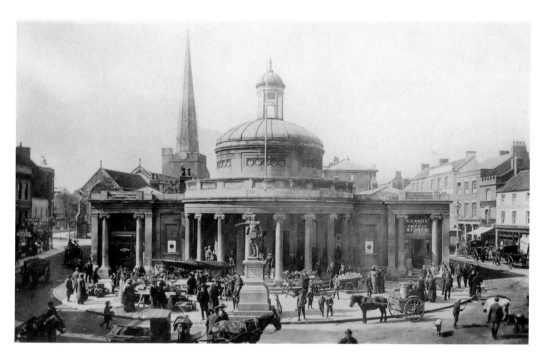

Market on the Cornhill, c. 1905

A busy view of the market from an upper-floor window shows people selling various produce. On the right a farmer, his boy and a dog are herding several cows and calves onto High Street towards Taylor's restaurant, now a branch of KFC. Flat caps seem to be the normal headgear but there are also a few bowler hats visible. A farmers' market is now held in Fore Street. The pillared building is now a café and restaurant.

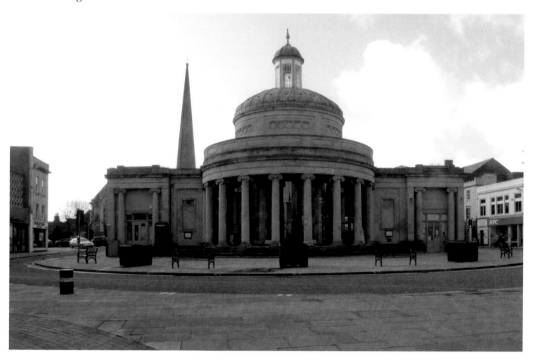

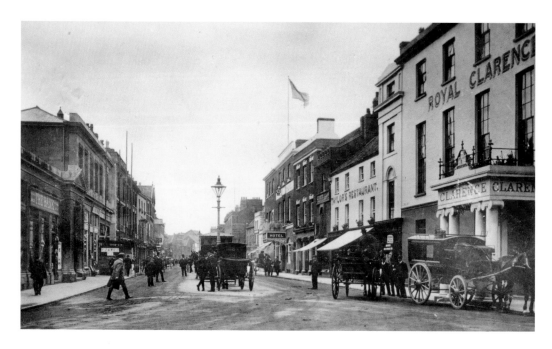

High Street Looking West, 1911

On the right are the Royal Clarence Hotel, Taylor's Restaurant, and the Bristol Arms Hotel. The Albany Hotel is on the left after The Bank, and another sign marks the location of the White Lion Hotel a little further along. Down the centre of the street is the taxi rank where horses and cabs await their fares. Today the Clarence is no longer a hotel, being split into three shops, and Taylor's Restaurant is a KFC fast food shop.

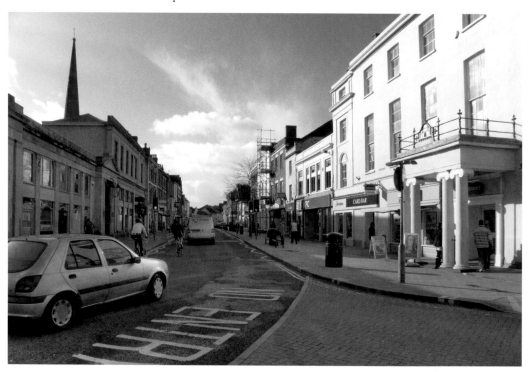

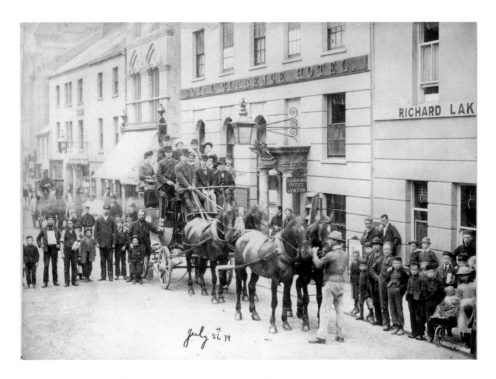

Lynton Coach Outside the Royal Clarence Hotel, 1879

Twelve people were crowded onto the top of the Lynton coach. Travel on the top of a coach was usually at half the inside rate, hence the high number of folk up there. A crowd of people, mostly children, stand posing for the photograph on either side of the coach, and a lone man holds the leading pair of horses steady. The Clarence Hotel building still stands there today, although slightly altered, and no longer used as a hotel.

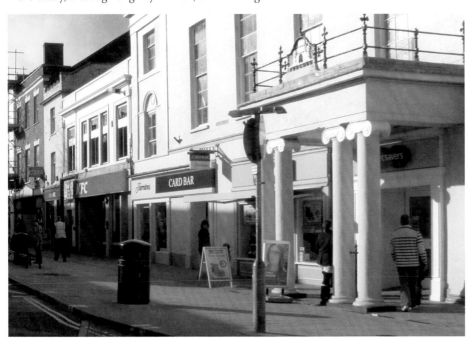

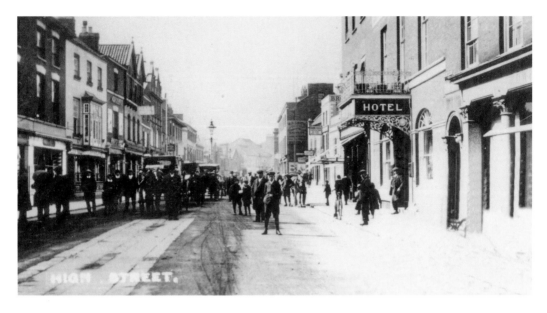

High Street and the Bristol Hotel, 1904

The hotel on the right was the Bristol Hotel, now a branch of Barclays bank. Just beyond it WHSmith has a large wall sign. WHSmith is now located in Fore Street. Almost opposite the Bristol Hotel was the Albany Hotel, and that building is now used as a betting shop.

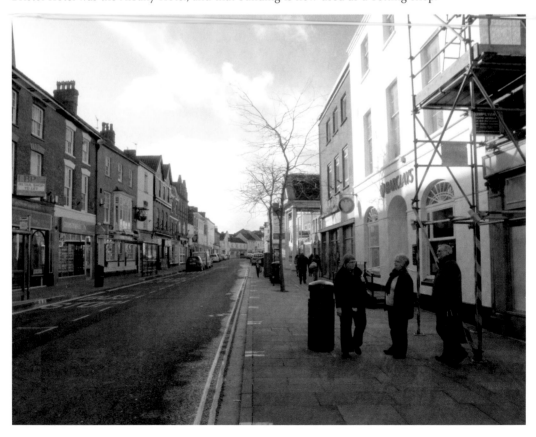

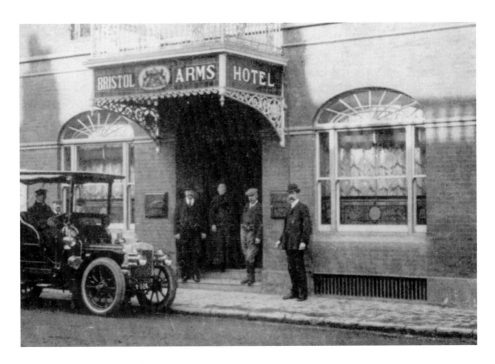

The Bristol Arms Hotel, 1908

A chauffeur is sat in an old car waiting outside the Bristol Hotel, while a lady and several gentlemen in bowler hats look on. The hotel, in High Street, is now a branch of Barclays bank. The window features still look much the same in the left window but not quite the same in the right one. The elaborate porch over the door has gone. As with many modern buildings there is now a wheelchair-friendly ramp to the door.

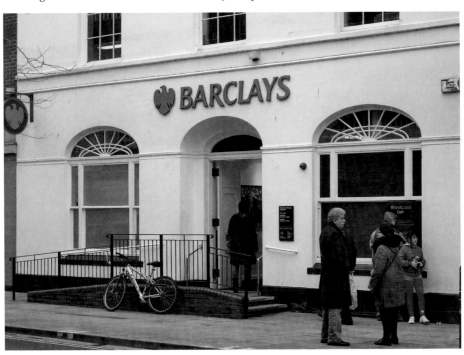

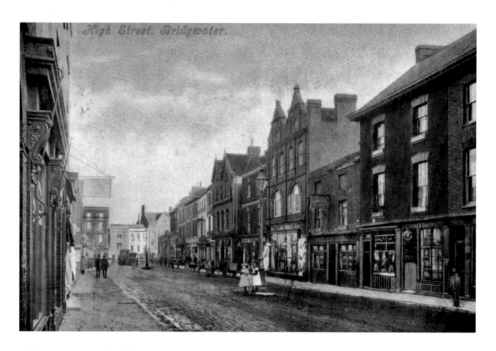

High Street, South Side, 1905

A very rare early coloured view of the south side of High Street, which shows the White Lion Hotel, now the Three Lions Hotel. Barnes the Tobacconist's, next door to it, is now Greenslade Taylor Hunt, an estate agent. Several horse-drawn carriages sit in the middle of the road near the north entrance to the Cornhill, and next to the booth that also stood there in the middle of the road.

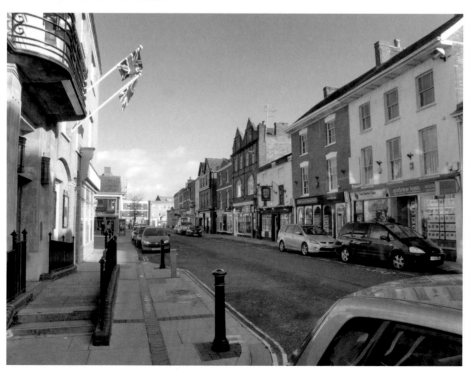

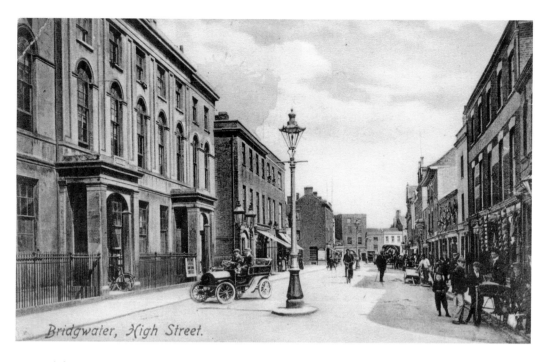

Bridgwater, High Street.

High Street, Looking East, 1911

A busy street scene looking east towards the post office building in the far distance. To the left is the town hall building with the pillared entrances. Street lamps were located along the middle of the road and there is just the one motor car in view. Today the roads are lined with parked cars. The old post office building seems to have been reduced by one storey, but most other buildings appear to be the same as in 1911.

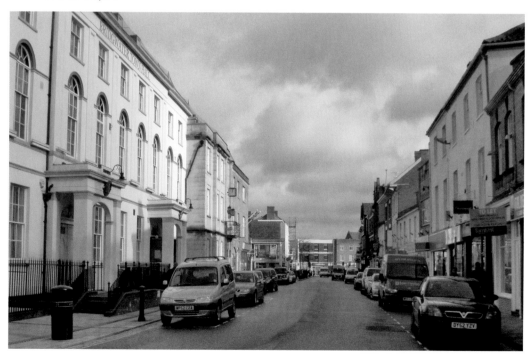

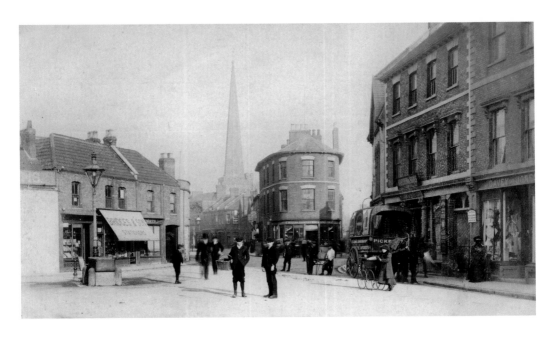

Penel Orlieu from the West, 1909

The unusual 'Roundhouse' building, occupied by the Western Counties Wine & Spirit Company, takes centre stage in this picture. The wagon and horse on the right outside Davey & Jones' shop looks like an early Pickford's removal vehicle. On the left was Bridges & Son Stationer's, now Remedies nightclub. What was once a quiet street with just a few people wandering across the road is now a busy junction with cars coming from all directions.

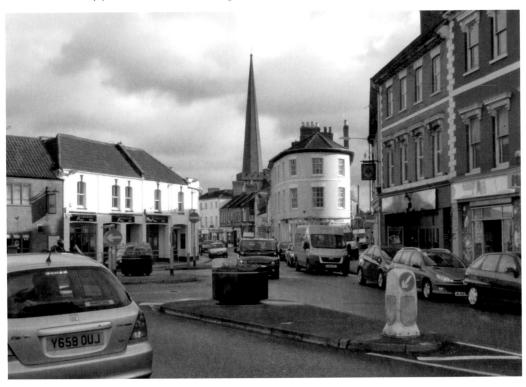

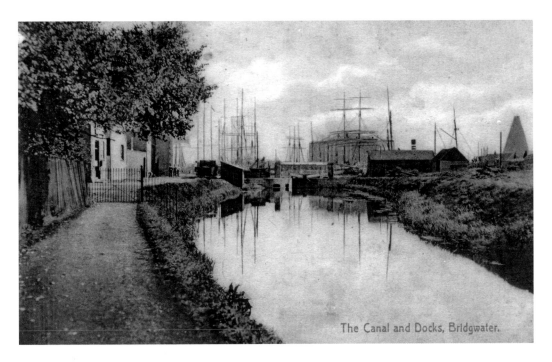

The Canal and Docks, Bridgwater.

The Canal and Docks, 1907

The glass cone and low brick buildings of the Holms Sand & Gravel Co. are visible on the right, and on the left, part of the buildings of the Oil & Cake Mills are visible. The ships are all gone today and near the Cake Mills the wall and gate are now missing and the whole building can be seen. Houses and high-rise flats are along the canal and around the edge of the dock.

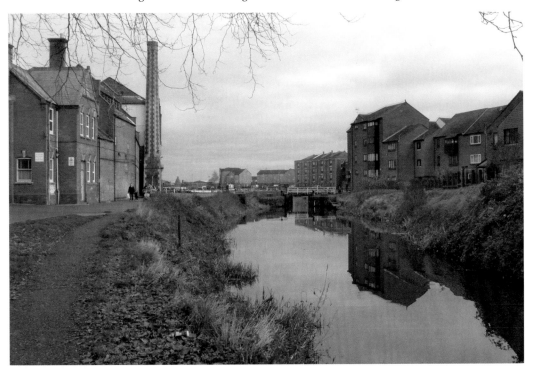

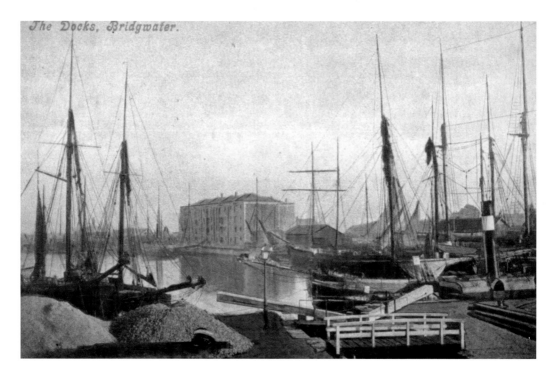

The Docks, Bridgwater.

The Warehouse and Docks, 1911

To the left of the warehouse it is possible to make out one of the six original Barham brickyards kilns. One still survives today, preserved as the Brick and Tile Museum. Blocks of flats have been built around the old dock, which was turned into a marina, hence the colourful houseboats moored up there.

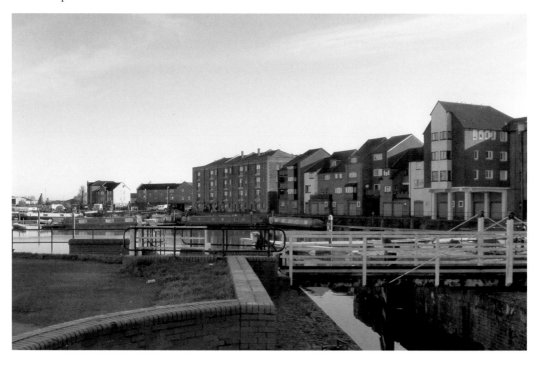

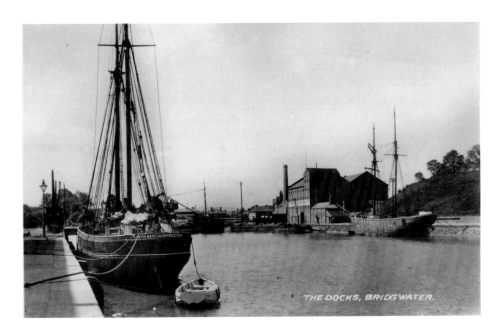

The Docks, Bridgwater.

The Docks and Mump, *c.* 1930

Trees stand on the summit of the Mump, which stands next to the British Oil & Cake Mills building. Railway goods wagons stand outside it. The boat *North Barrule* of Chester sits against the south side of the dock next to the canal entrance. At the far end next to the canal entrance the Holms Sand & Gravel building is just visible. Today blocks of flats surround the dock, which itself is filled with houseboats. The only original building standing there is the Bowerings building.

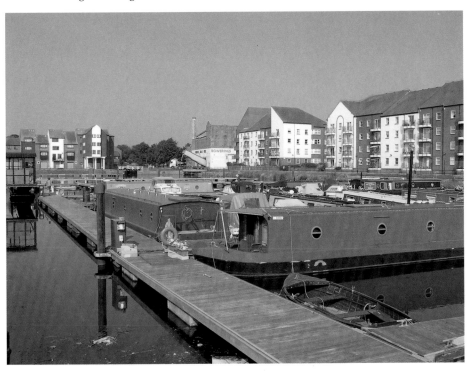

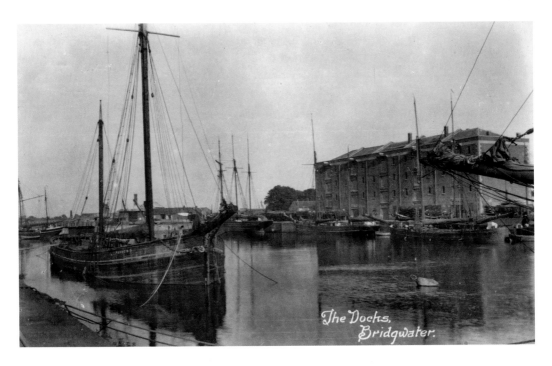

The Docks,
Bridgwater.

The Docks Looking East, 1920

The Bridgwater ketch *Parkend*, owned by Sully & Co., formerly a schooner, and built in Ipswich in 1873, lies low in the water on the north side of the dock. Today the docks, which were converted to a marina, have only houseboats and empty berths. The warehouse building today looks relatively unchanged from the early view.

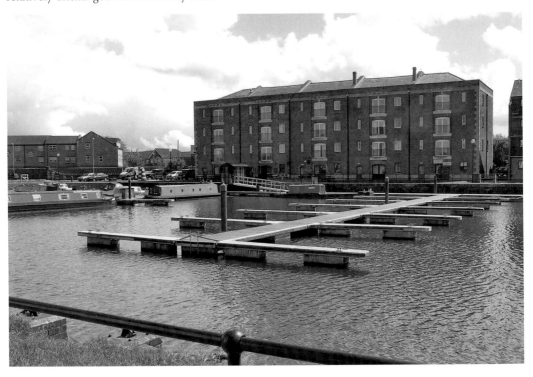

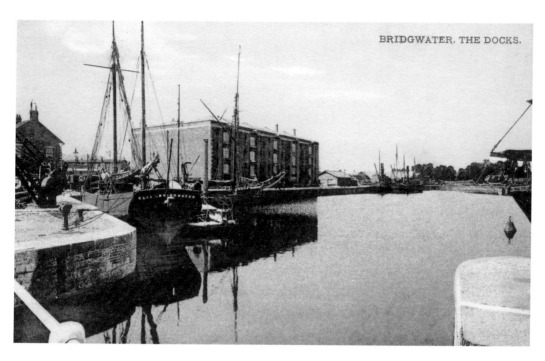

The Docks Looking West, 1927

The boat *Eliza* of Bridgwater is tied up on the left next to the black crane hoist. The crane is still there today and the warehouse looks pretty much the same, although it is now the Admirals Landing Pub on the lower level, and flats in the rest of it.

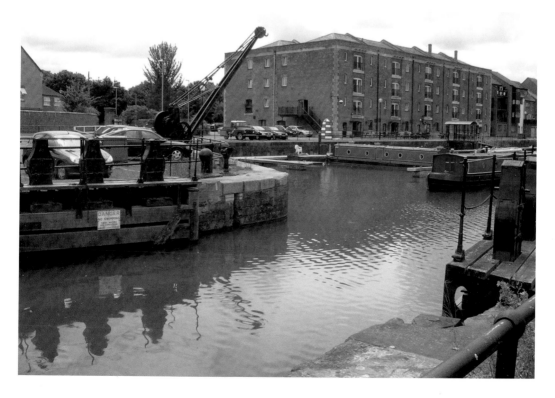

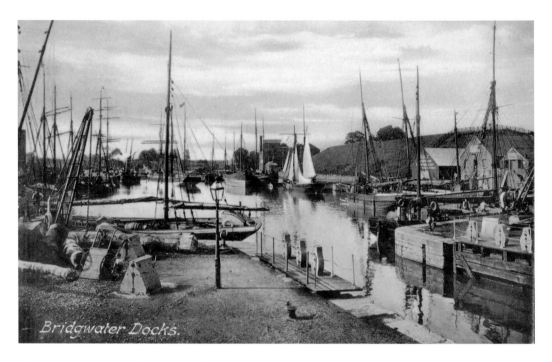

Bridgwater Docks.

The Docks and Mump from the Bridge, 1913

A rare view looking north-west towards the Mump shows a multitude of unidentified sailing vessels and one steamboat. One of the three warehouses on the right (east of the mound) is identified as Peace. The inner lock gates were open, and the old crane can be seen to the south side. One steam tugboat can be seen in steam.

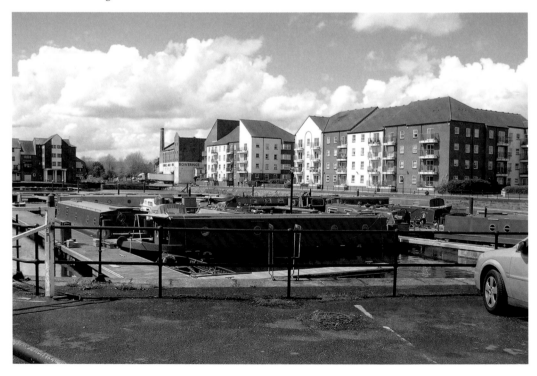

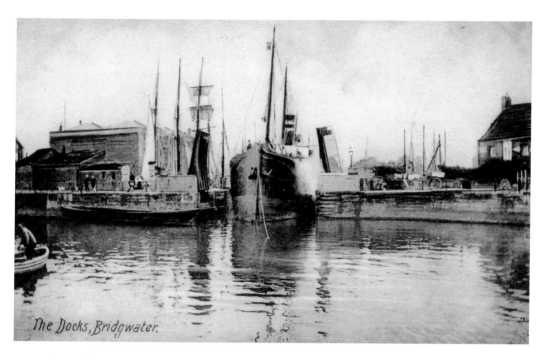

The Docks, Bridgwater.

The Docks and Lock Gates, *c.* 1910

A very rare early view of a steam ship passing from the dock into the tidal basin with the road bridge elevated to allow it to pass through. A horse and cart waits on the north side of the bridge, near the buildings of Russell Place, and the offices of Sully's coal business can just be seen on the extreme left. Today the small buildings near the warehouse are gone but most other features remain.

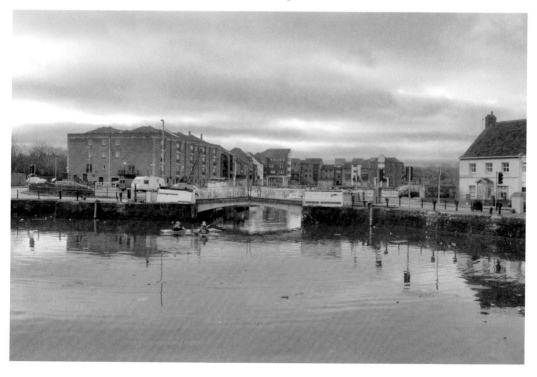

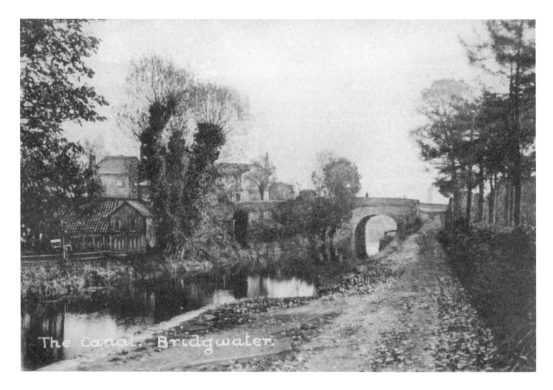

The Canal at Taunton Road, *c.* 1905
Looking east along the canal towards the road bridge over the A38 road to Taunton. The canal was constructed in 1827 from Taunton to Huntworth. This stretch formed part of an extension to the docks, which were added in 1841. Not much has changed over the years. At least one of the original houses is still visible on the left but the bridge looks substantially unchanged. The trees on the right are also no longer there.

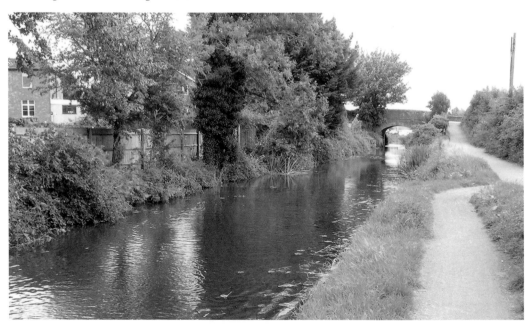

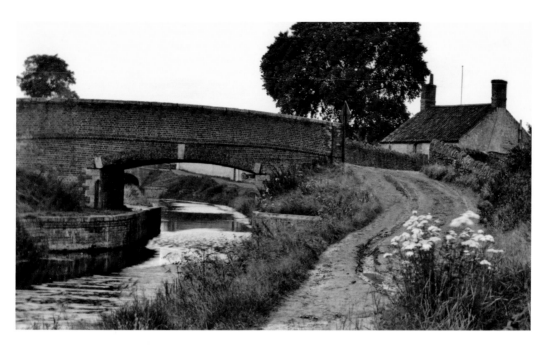

The Canal Towpath at Old Taunton Road, *c.* 1920
The Bridgwater & Taunton Canal passes under the old Taunton road bridge. The bridge has been rebuilt but the cottage in the original picture looks much the same today, although the large tree next to it is now gone. Along the right-hand side is the scaffolding from the new development on the old Hamp industrial estate, a large number of blocks of flats next to the canal and the river.

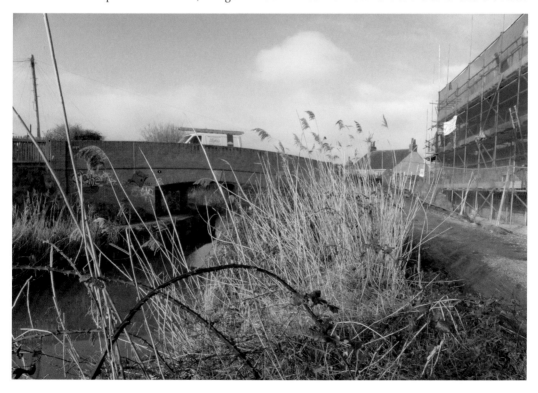

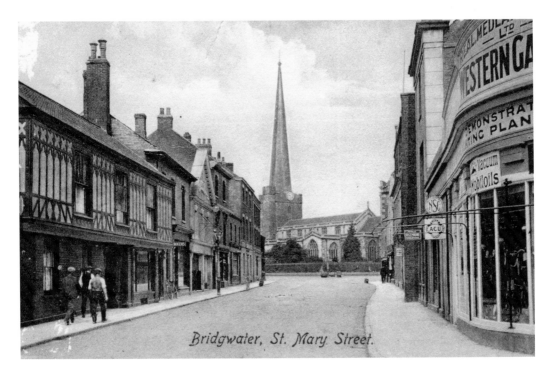

Bridgwater, St. Mary Street.

St Mary Street Looking Towards the Church, 1910

Looking along St Mary's Street towards St Mary's church, you can just make out the horses' water troughs in the road at the junction. Real Medland & Wills Ltd is on the right-hand side, and signs saying ACU (Auto Cycle Union), NSC (National Society of Chauffeurs), and 'Public Telephone Call Office'. On the other side is the Tudor Hotel, still there today. Very little has changed other than the ownership of the various premises.

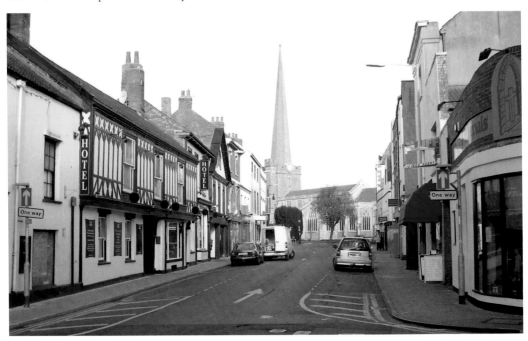

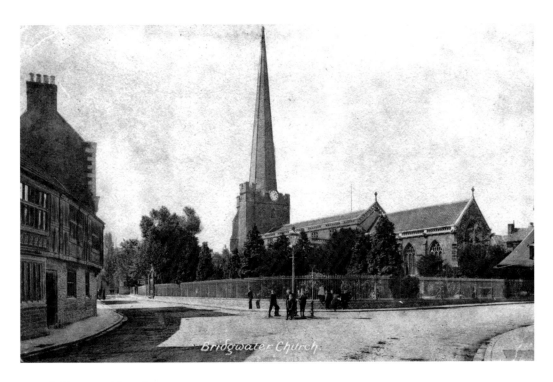

Bridgwater Church, 1903

A group of around ten young children are standing around the gas lamp with St Mary's church beyond the railings. The time was 1.10 p.m. according to the church clock. High railings were all the way around the churchyard, which was full of trees, but the railings are gone today. On the left is the Mary Court building, now the Carnival Inn. The taller building at left was the Waterloo Inn, now known as the Bridgwater Arms.

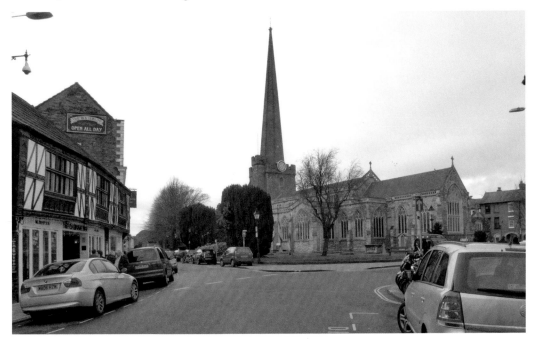

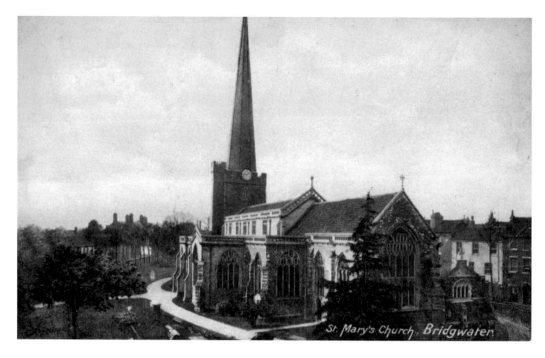

St Mary's Church from the East Side, 1910
A slightly elevated colour view of the church showing the east window. The church was probably built in the twelfth century, with the first vicar being recorded in 1170. The spire was built in 1367. The view today is much the same. The modern sign says, 'No Loading at any time.'

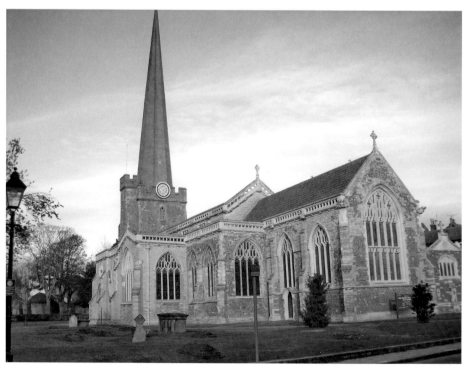

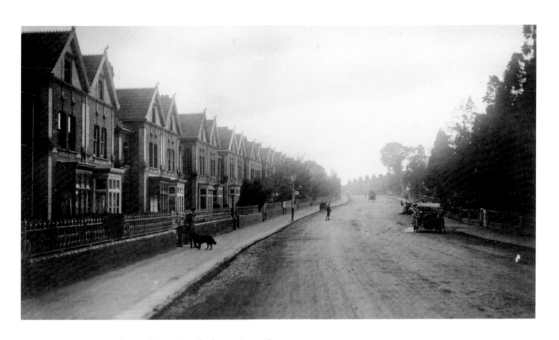

Taunton Road, Looking South from Broadway, 1912
An early view of Taunton Road looking towards the canal bridge, with just one old car parked up on the right, and one horse and cart coming along in the middle of the road. Lots of trees can be seen along the right-hand side of the road and they may still be the same ones that line the road today. On a gloomy day the view depicts loads of traffic queuing to get into the town.

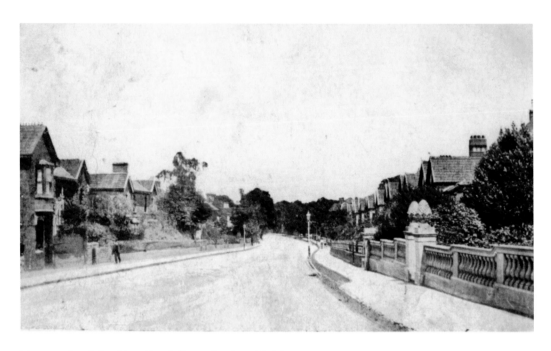

Taunton Road, Looking North from the Canal Bridge, 1905
A deserted view looking from the canal bridge towards the town. Not a car or horse is visible on the road. On the right are two gate pillars topped by giant acorns. Today there is a house there called Acorn Lodge, but the pillars are long gone. In the distance a long line of traffic heads towards the Broadway junction.

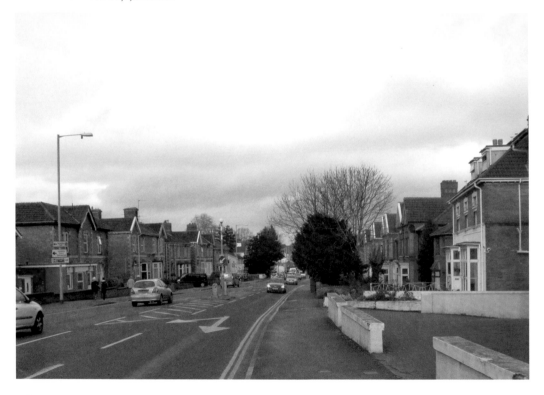

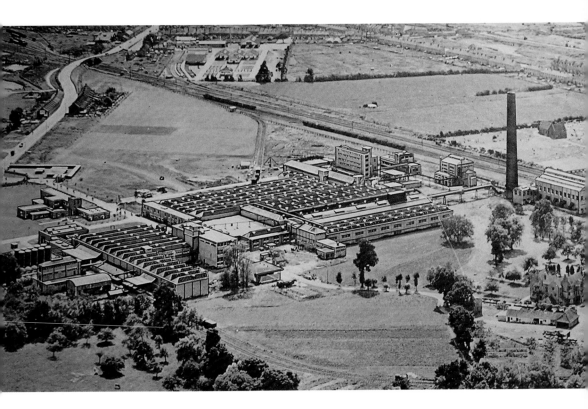

Aerial View of British Cellophane, c. 1935

It is thought that this picture used to hang in the boardroom of the old British Cellophane Limited factory. Built during the mid-1930s, it eventually started making cellophane in 1937. The largest employer in Bridgwater, at its height there were some 3,000 people working there during the 1970s, producing around 40,000 tons of cellophane film per year. The factory closed in 2005. No trace of it survives today; every last part has been removed or converted into piles of rubble.

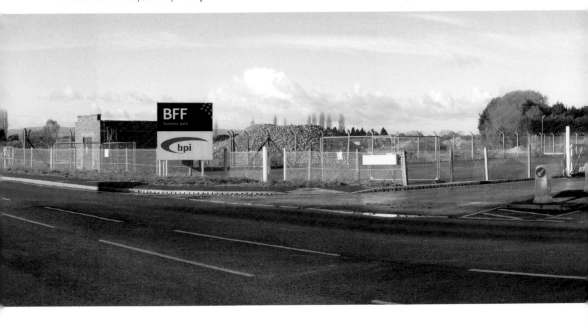

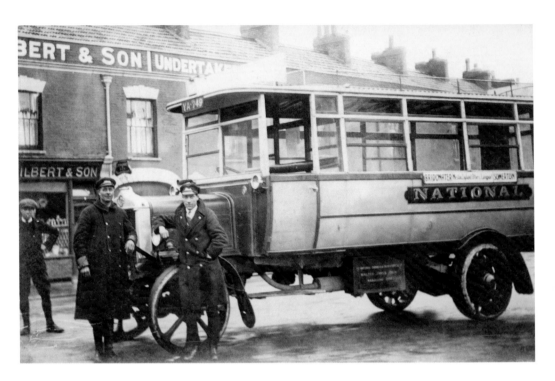

National Bus at St John's Street, *c.* 1914
Markings on the side of this National bus indicate that it operated between Bridgwater, Othery, Langport and Somerton. The man on the left, wearing reflective wrist bands, was the driver; the other man was the conductor. This view was taken outside Gilbert's Undertaker's at the east end of St John's Street at the junction with Station Road. J. E. Gilbert & Son, funeral directors, are still there as can be seen in the modern picture.

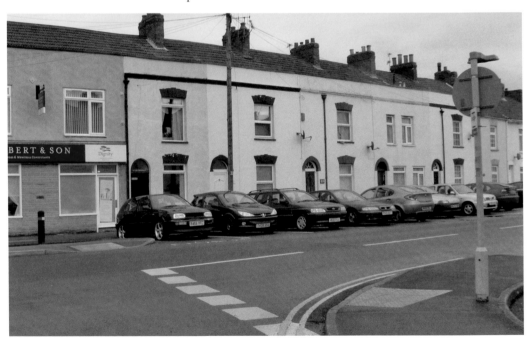

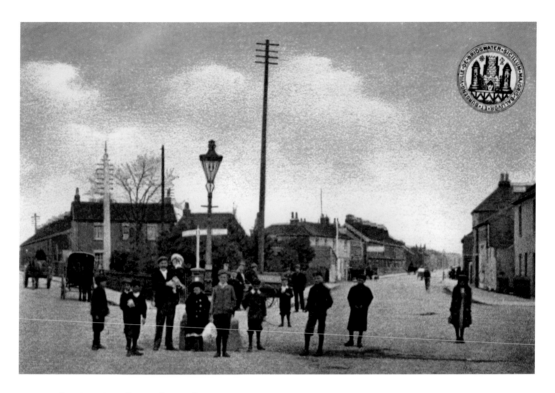

Bristol and Bath Road Junction, 1905

The Bristol (A38) and Bath (A39) roads meet at the Cannon junction. A large group of people, including children, stand all across the road in front of the water trough, with just the odd horse and cart in view. Behind the group are a red letterbox and a signpost. This junction was known as 'The Cannon' by local people because of the Crimean cannon installed there in 1886. Today this is a very busy roundabout serving five roads.

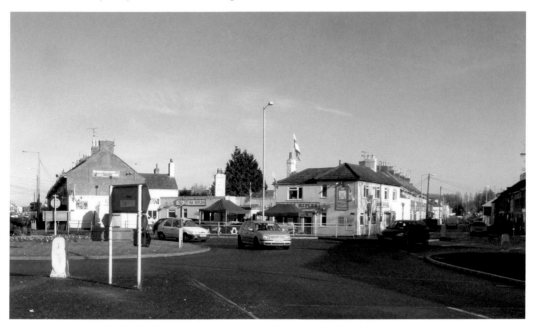

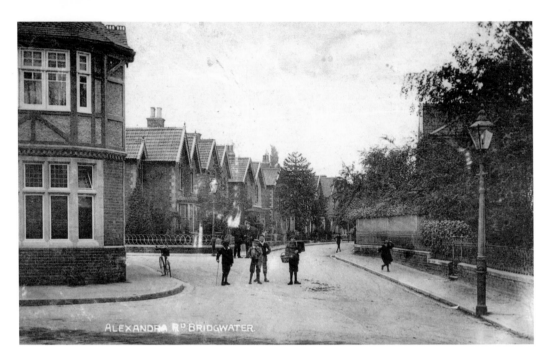

Alexandra Road, *c.* 1910

Built in the 1880s, these houses were initially known as Alexandra Villas. This lovely old view shows a group of people, mostly children, stood on the corner where the Malt Shovel Inn is situated on the left, with the houses in the background. The inn is still there today, sat next to the busy A39 and the houses themselves still look pretty much unchanged.

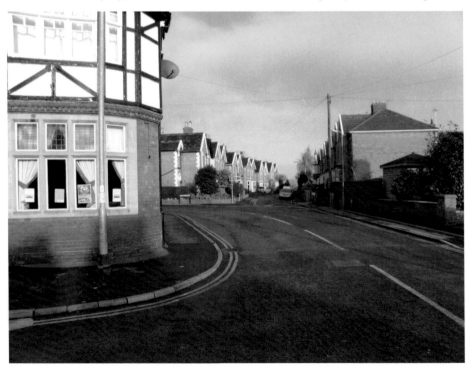

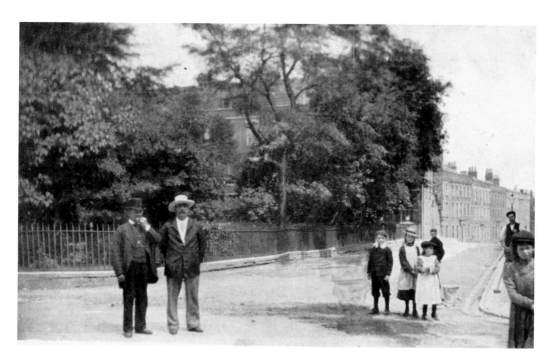

King Square, 1905

This rare view shows a bushy area surrounded by railings, and several groups of people posing for the photograph. A workman, in waistcoat and cap, pauses for a moment to watch the proceedings, and two important-looking gentlemen also pose. Again the modern view is dominated by parked cars, the low wall and railings look slightly different, but the buildings are much the same.

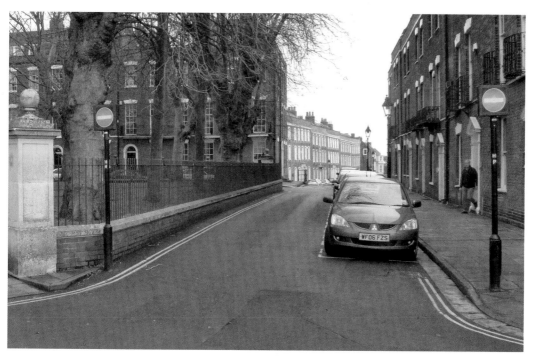

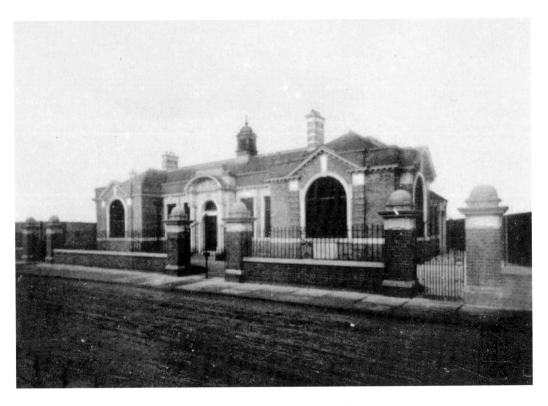

The New Police Station, 1913

This rare photographic postcard shows the new police station building. H. W. Pollard was Justice of the Peace, R. O. Sully was Mayor, W. H. Williams was Superintendent, and W. J. Davey was Chief Constable. The foundation stone was laid by H. W. Pollard on 3 August 1911, and the building formally opened by Mayor R. O. Sully on 28 January 1913. Today the police station occupies a new building to the right, and this building is now part of the magistrates' court.

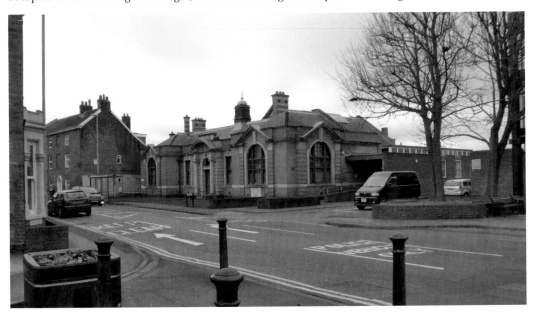

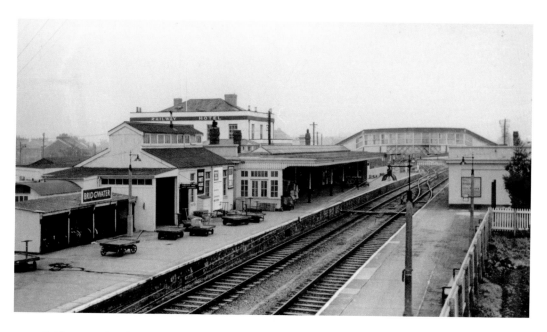

Bridgwater Station and the Railway Hotel, 1962
The top of the Railway Hotel can just be made out behind the station buildings. Long since demolished it is now part of a car sales garage. The bike sheds and parcels and left luggage buildings in the foreground are no longer there, replaced by a car park along the back of the platform.

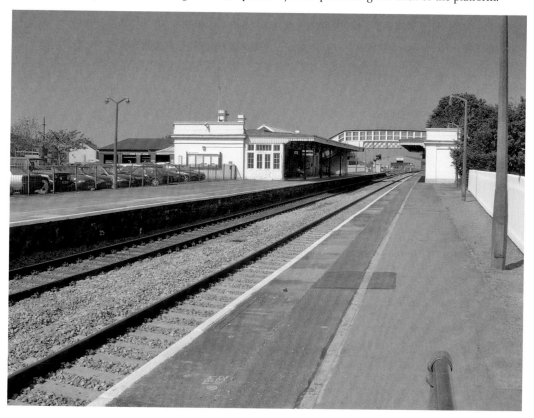

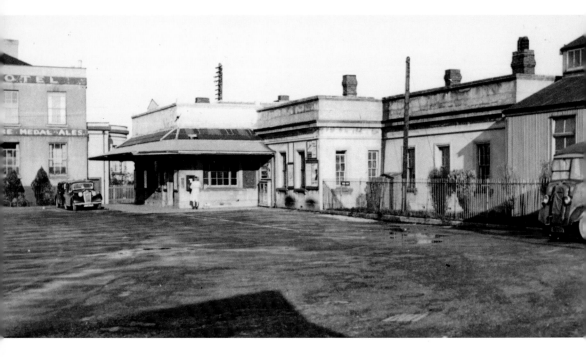

The Railway Station, 1947

This lovely old photograph shows the station buildings and the Railway Hotel, built when the broad-gauge railway came to the town from Bristol in 1841. The Railway Hotel, long since demolished, now has a car repairer and MOT centre in its place. The station buildings are largely unchanged.

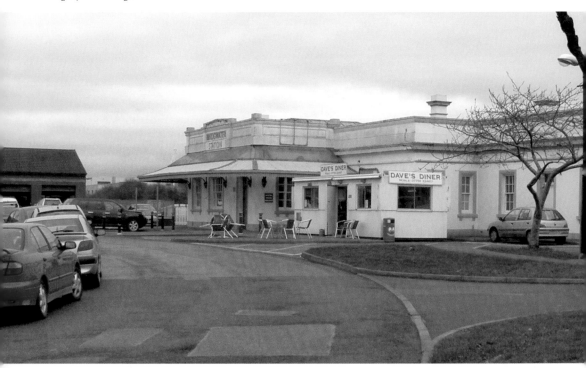

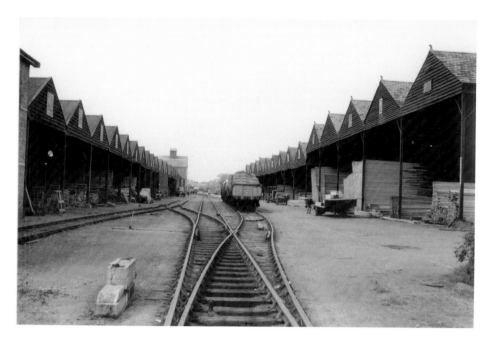

The GWR Woodsheds at the Clink, *c.* 1950

This rare view looks along the branch railway that led off the main line just north of Bridgwater station. It went through the timber yard, towards the black telescopic bridge and then on to the docks. The photographer would have been stood about where the railway crossed the A38 Bristol Road near the Canon junction. Nothing from the original picture is visible in the modern view, taken from approximately the same place.

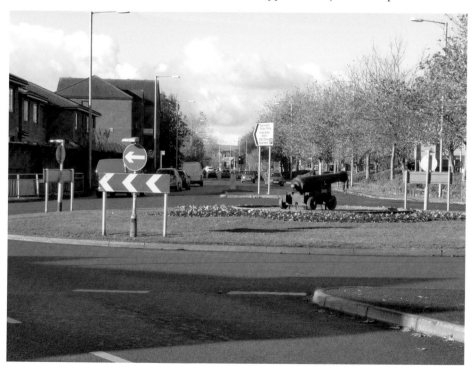

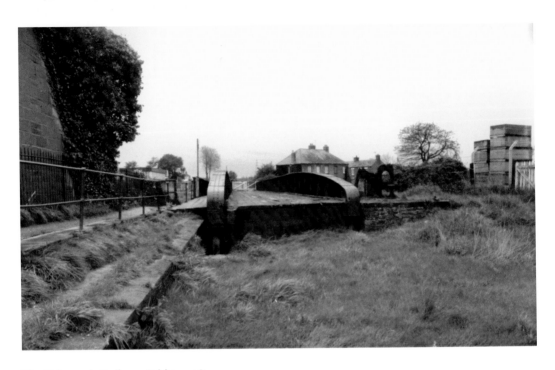

The Telescopic Railway Bridge, 1981

This photograph was taken by the author in 1981 not long before the bridge was used as a temporary road crossing from 1982/83. After the Chandos Bridge next to it was completed in 1988 it reverted back to a footpath and cycle crossing, which is how it remains to this day. The Hope & Anchor pub is the building to the right of the bridge in both pictures.

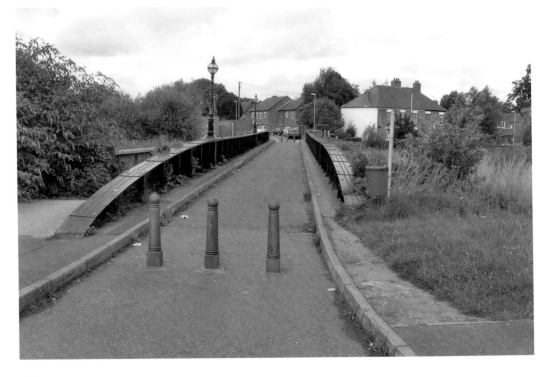

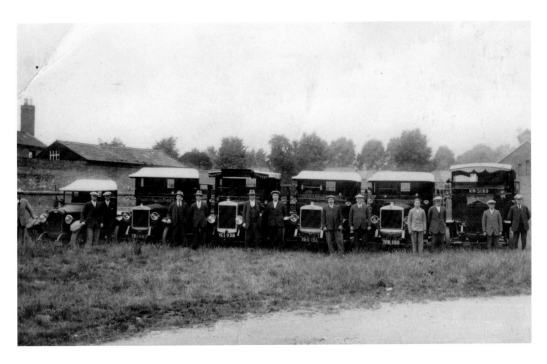

Brewery Lorries at Northgate, *c.* 1909
The Starkey Knight & Ford brewery was built at Northgate around 1890. Previously it had been in the High Street. This lovely clear photograph shows five of their lorries, one car, and thirteen men. On the back of the postcard it says 'Len Summerhayes, third person from the left'. Today it is difficult to identify anything from the original picture as the brewery was demolished in the sixties, and the Sedgemoor Splash, also built there, was demolished a few years ago.

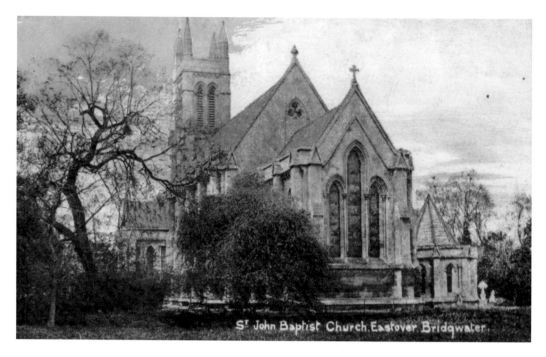

St John Baptist Church, Eastover, *c.* 1920

The three-part east window of this huge church, the nave and the tower are all easily visible from the vantage point that the photographer adopted to take the original picture. Today, standing in Capes Close, you can just about see the roofs and top of the tower; everything else is obscured by trees and buildings.

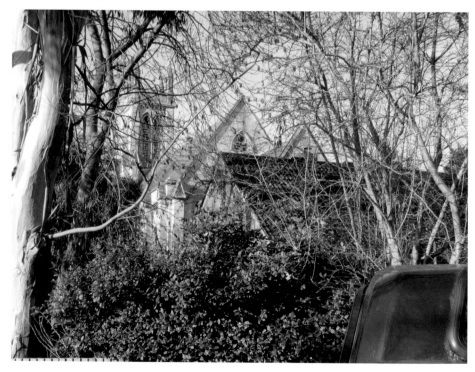

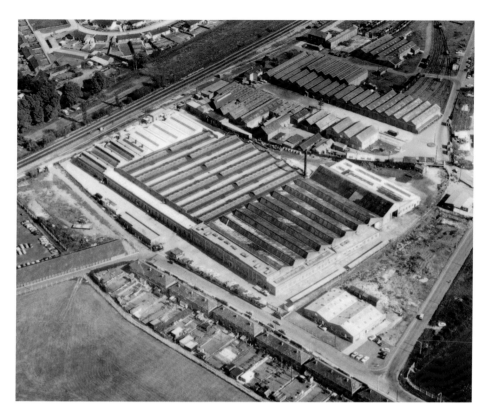

Aerial View of Wellworthy, Colley Lane, *c.* 1955

The picture shows the full extent of this factory, which at its peak in the 1980s and 1990s produced around 40,000 diesel and petrol pistons per week. Its American owners decided to close it during 2004/05 and the work was transferred to Turkey and Poland, with most of the workers made redundant. In 2012 the factory was razed to the ground and so now there is no trace of it whatsoever, barring the ornate iron gates at the west entrance.

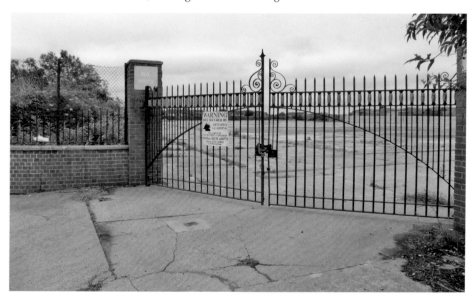

Around the Villages

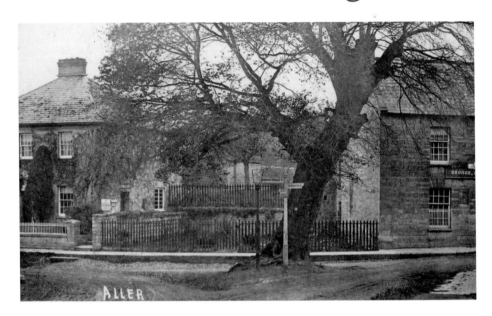

Aller, the Pub, 1925

The Old Pound Inn, formerly the White Lion Hotel, a Grade II listed building, occupies a prime position on the main road through the village. The large tree in the old picture has gone, replaced by a new tree in an almost identical position. Other than that the scene is much the same today.

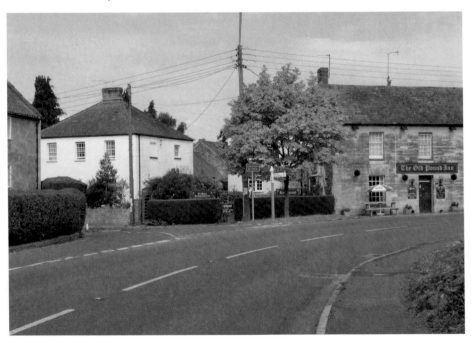

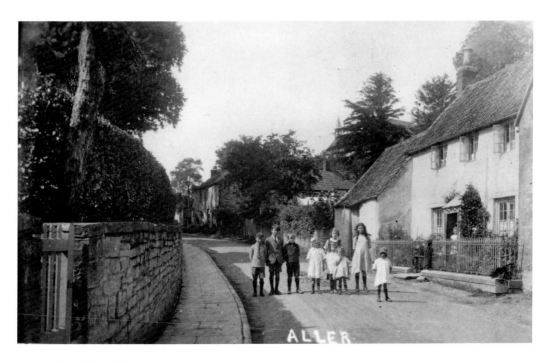

Aller, Ridley Hill, 1924

A group of nine children pose for the photographer by standing in the middle of the road at Ridley Hill, just along from the Old Pound Inn. The old school building can just be seen behind them in the trees. Today the brick wall on the left and the railings in front of the cottage on the right are gone and the road is a busy through route to Langport.

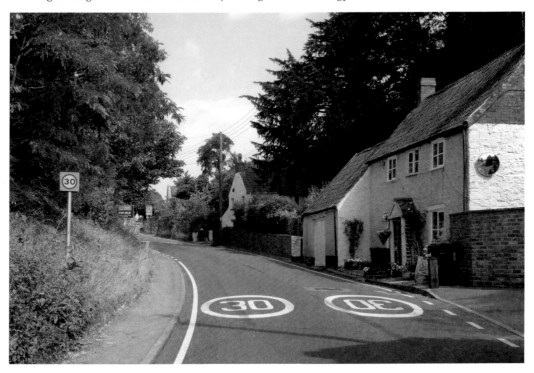

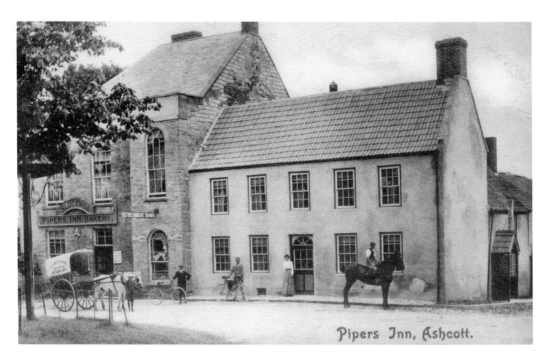

Pipers Inn, Ashcott.

Ashcott, Pipers Inn, c. 1905

A lovely white horse with a two-wheeled baker's delivery cart stands next to Pipers Inn. A sign on the wall of the inn states, 'Slocombe, Pipers Inn Bakery', and other signs say 'Refreshment Rooms', 'Rowntree's chocolate', and on a window 'Turog', a Cardiff-based supplier of flour since 1903. Today the scene is pretty much the same but the Pipers Inn is now in the middle of a busy junction with cars speeding past on two sides.

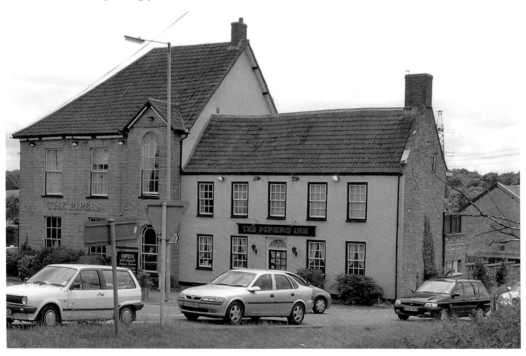

Bawdrip, New Road, c. 1905

The buildings on the hill in the distance are the remains of Knowle Tower, a sham castle built in 1870 for Benjamin Greenhill of Knowle Hall. A woman stands at the garden gate of her pretty thatched cottage, the only building along that side of the road. Today the fields along the right-hand side of New Road are home to a series of houses and bungalows. The castle was demolished many years ago.

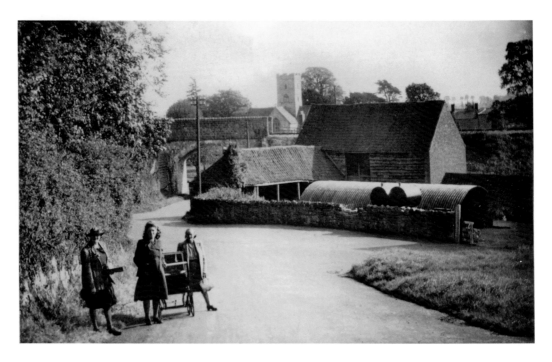

Bawdrip, the Railway Bridge, c. 1930
Three ladies with a pram pose for the photographer in this view looking down to the railway bridge. The railway embankment appears to be in good order, and through the arch of the bridge can be seen apple trees, and above the bridge the church is visible in the distance. Today the original stone barns are gone, and under the bridge the orchard has disappeared, Church Farm having been demolished to make way for the present housing estate.

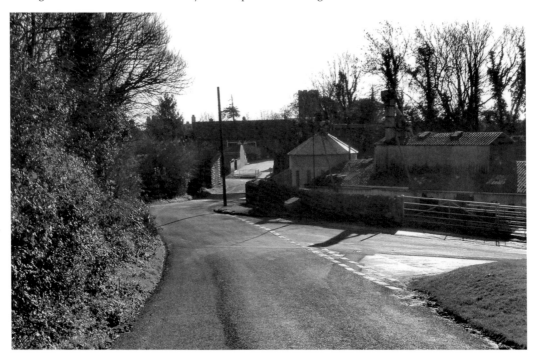

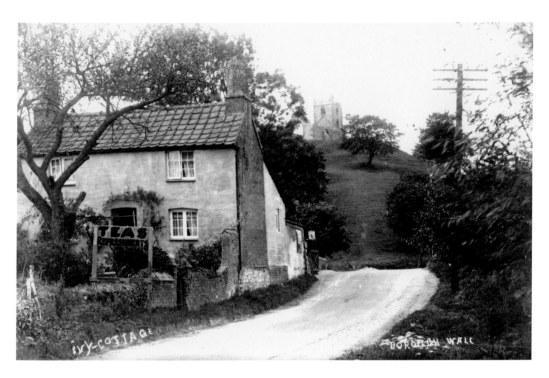

Burrowbridge, Ivy Cottage, Borough Wall, *c.* 1910

Ivy Cottage is offering teas and refreshments. The road was just a narrow stone track at the time. Today the road has been widened and the hump removed, and the tree on the Mump has gone. Borough Wall, the bank on which a number of houses including Ivy Cottage were built, was a flood prevention measure. The fields on the moors, to the left of the bank, still flood during winter months.

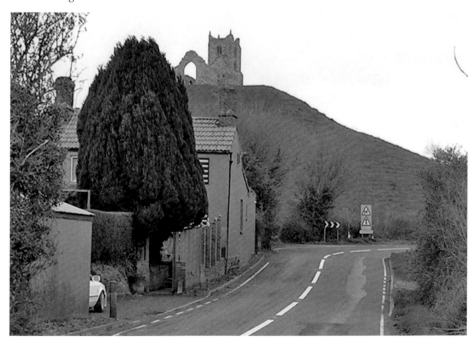

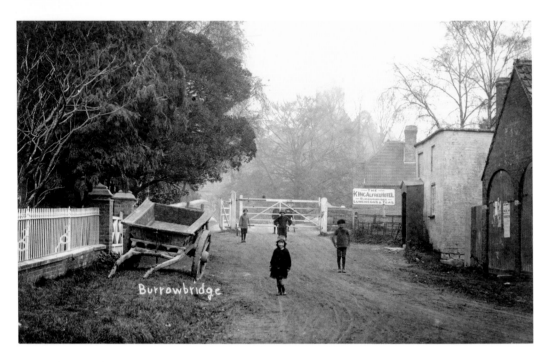

Burrowbridge, the Toll Bridge, 1905

Children pose next to the tollgates, with the King Alfred Hotel in the background. A two-wheeled cart sits on the side of the muddy road, and Burrow Mump can just be seen through the mist. The tollgates on the bridge are now gone, and the buildings on the right have just a wall and doors remaining. The ornate gate pillars and fence along the left side have gone, and on the right side a bright red telephone box has now appeared.

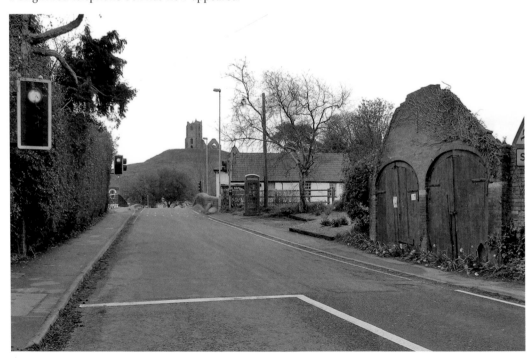

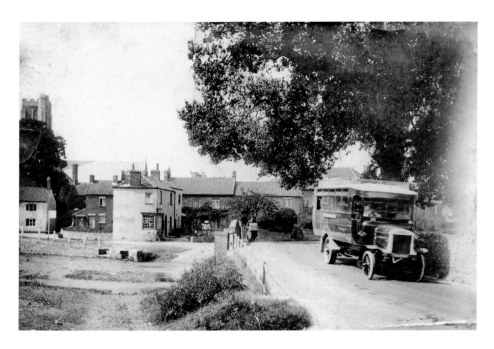

Cannington, Brook Street Bridge, *c.* 1910

The local bus makes its way south along Brook Street, over the bridge that went over the Brook. The building to the left of the bridge houses a small shop. The church tower can just be seen at top left. Today this road is relegated to a quiet side road, the main road through the village now passing to the right. The large tree is still there dominating the view.

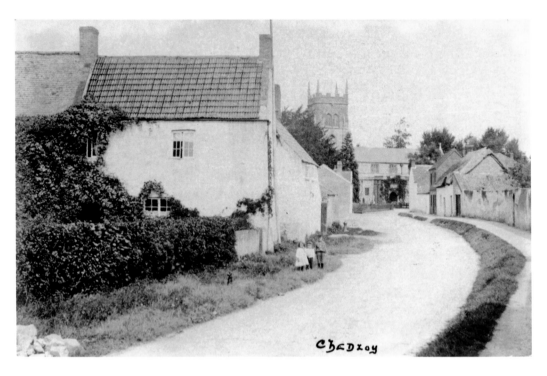

Chedzoy, Looking Towards the Church, 1905

Three small children pose for the photographer on the grass verge next to Court Farm house. Some of the buildings in the distance on the right are no longer there, and the high wall has become a low brick wall where bungalows are now situated.

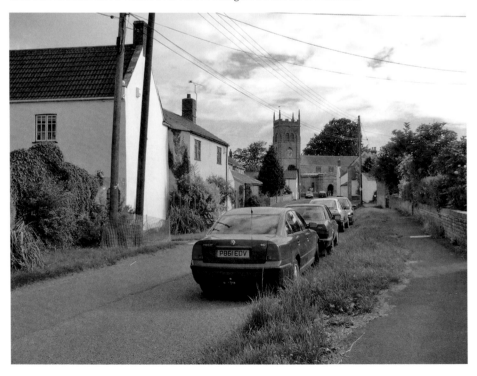

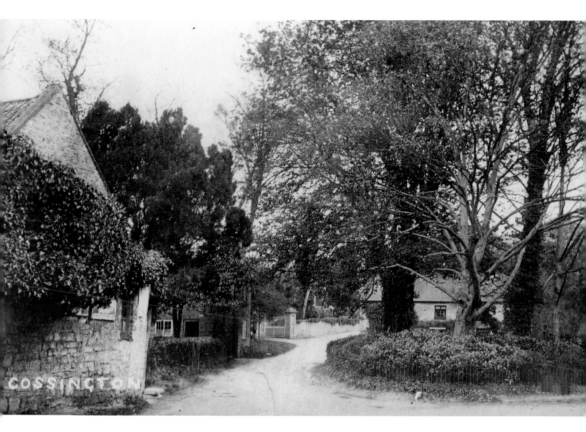

Cossington, the Triangle, *c.* 1910

Just beyond the triangle are the pillars and gates which were the entrance to the manor house that stands next to the church. The stone pillars are still there today but not the iron gates. The hedge and gate in the foreground on the left marked the entrance to the old post office, now closed, and iron railings that surrounded the triangle on the right are also no longer there.

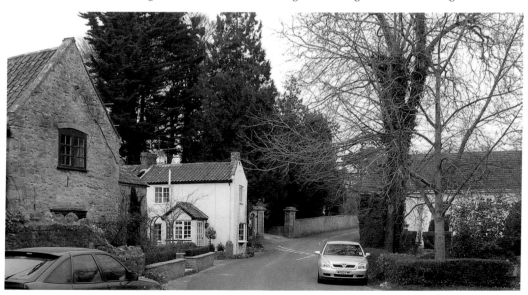

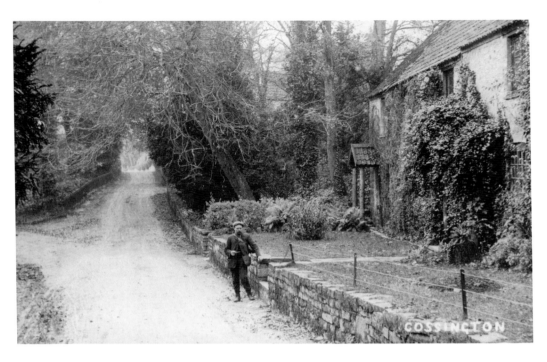

Cossington, the Postman, 1911

The local postman pauses for a moment as the photographer takes his picture. He stands there with a letter in his hand and a satchel over his shoulder leaning against the wall of what is now Keepers Cottage. Today the road looks to be in better condition, and a new house has appeared beyond the cottages. Apart from that the scene has changed very little in 102 years.

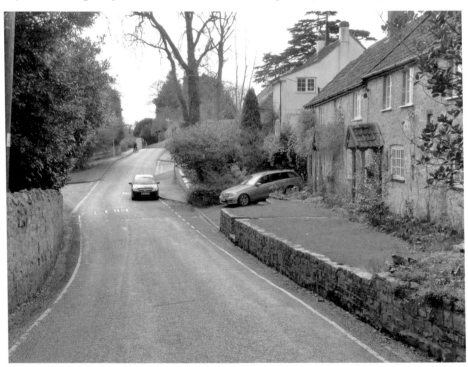

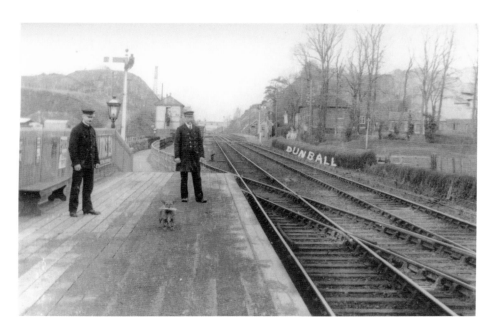

Dunball Station, *c.* 1905

Looking north along the Up platform, the stationmaster stands with his little dog and another railway worker. The John Board cement and lime works can be seen on the right-hand side, and behind it the bank rose steeply. Today much of that bank has been removed to make way for the M5 motorway, out of the picture to the right. Few of the original features survive today as a high-speed train flashes past heading towards Bridgwater.

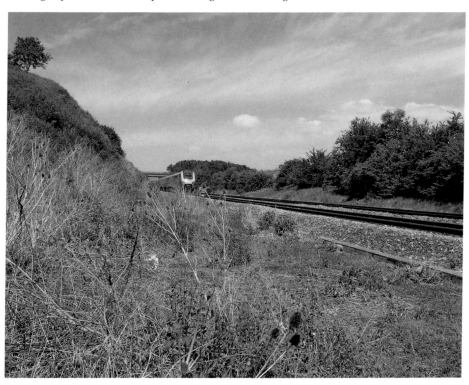

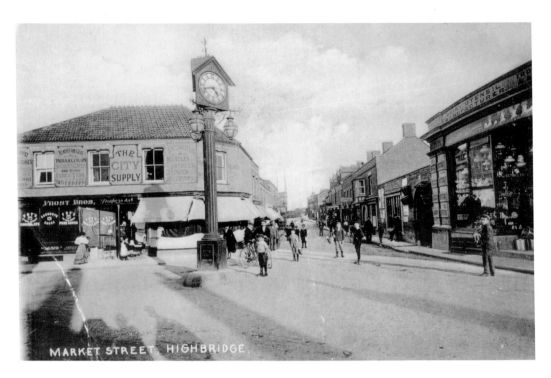

MARKET STREET, HIGHBRIDGE.

Highbridge, Market Street, 1906
A lovely old view of the town clock looking along Market Street towards the railway station. Lots of people, mostly children, have stopped and turned to pose for the photographer, obviously a rare event in those days. The clock was relocated nearby and the junction is now a busy roundabout.

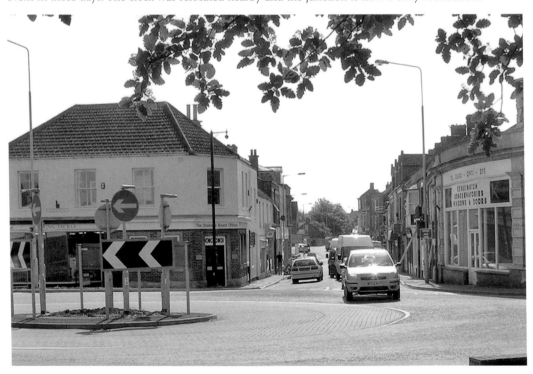

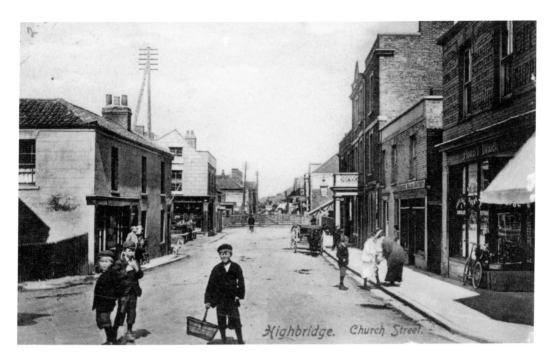

Highbridge, Church Street, 1905

The railway crossing gates are across the road in the distance so a train had just passed by or was approaching. The footbridge is visible on the right just beyond the George Hotel. Just past Frost Bros shop on the right was the Highbridge Bacon Factory. Children stand in the road, and a horse stands patiently harnessed to a cart. Today some of the houses on the left are gone and the railway was taken up many years ago.

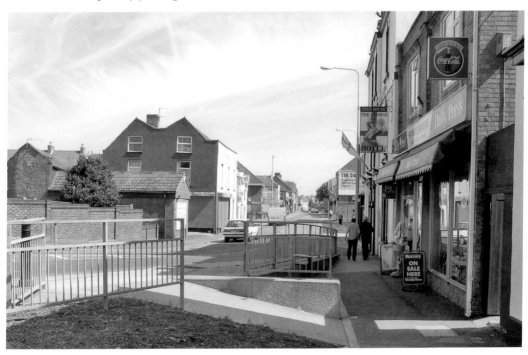

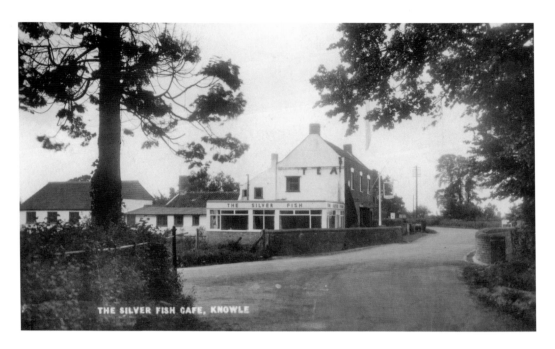

THE SILVER FISH CAFE, KNOWLE

Knowle, the Silver Fish Café, c. 1930

Looking south across Crandon Bridge towards the building then known as the Silver Fish Café and Hotel. On the left is one of the two fenced triangles that used to sit in front of Knowle Hall entrance gates. Had you wanted to go in the direction of Glastonbury on the A39 you would have kept to the left of the two triangles. Today this is a very busy junction with traffic lights providing an access road to the M5 motorway via Puriton Hill.

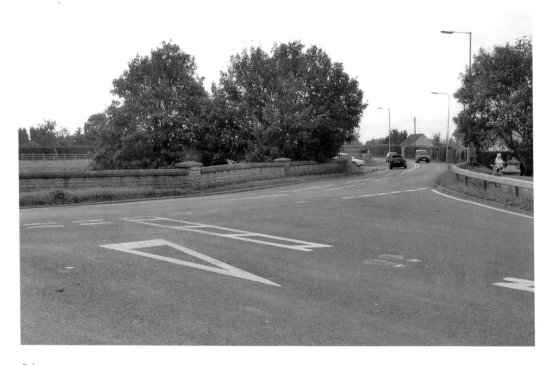

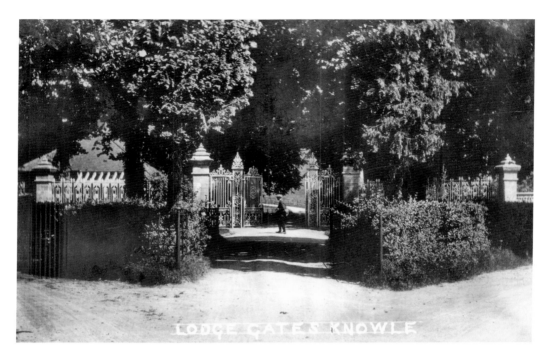

Knowle, the Lodge Gates, 1915

A long-forgotten view of the grand pillared and gated entrance to Knowle Hall, next to the junction at Crandon Bridge. There were two triangles, between the entrance gates and the bridge, containing hedges and trees surrounded by metal fencing. Lodge and hall traffic entered and exited between them. Other traffic passed behind or in front so visibility must have been poor. Very little of this scene survives today making it difficult to identify.

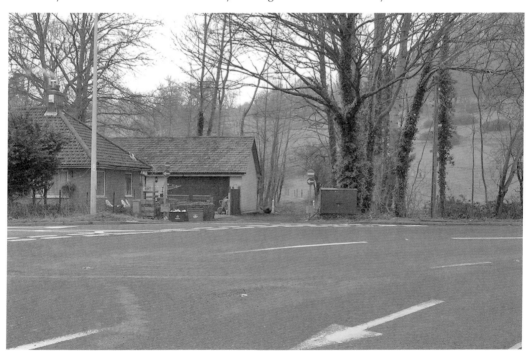

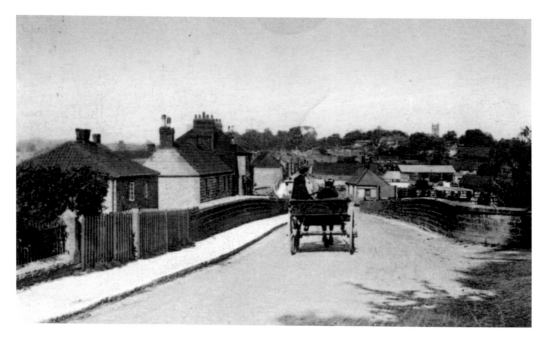

Langport from Westover, 1908

A lovely coloured view from near Frog Lane, just below Herds Hill, looking east along the road towards the bridge and town. A single horse and cart trundles down the road. To the right of the bridge several railway goods wagons marked 'Sully & Co.' can just be seen. The railway ran under the road bridge to Langport West station off to the right-hand side. Little has changed save a few new buildings in the distance.

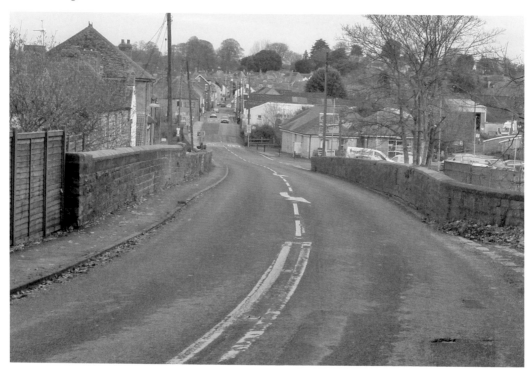

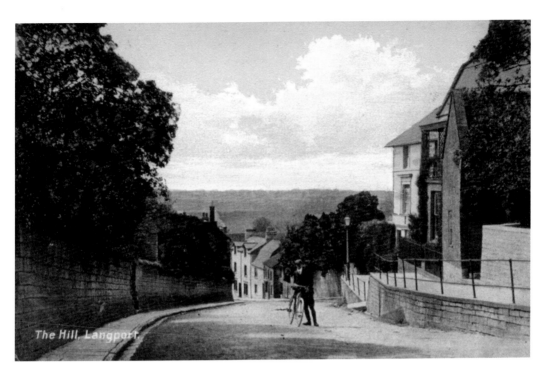

The Hill, Langport.

Langport, the Hill, 1907

A lovely early view looking west from the hill, with just one lone cyclist in the middle of the road looking at the cameraman. A new building has appeared on the left partway down the hill, and the previously empty road is now cluttered with parked cars.

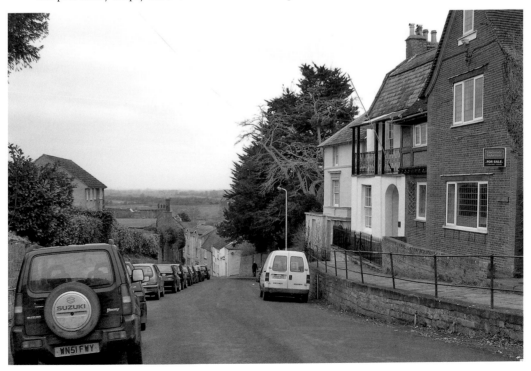

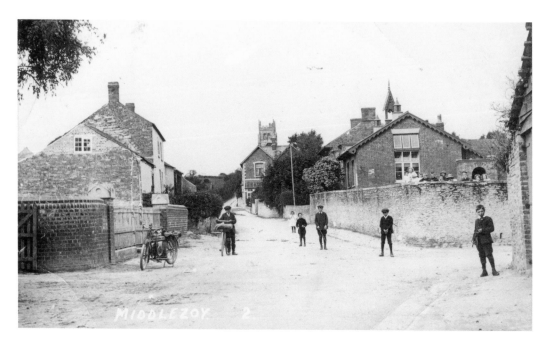

Middlezoy, the School, 1908

A classic photograph of the school, with children in the playground and in the road, and an old motorcycle parked along the road. A large tree now hides the church tower, and cars are parked in the road, but the view has changed very little over all those years.

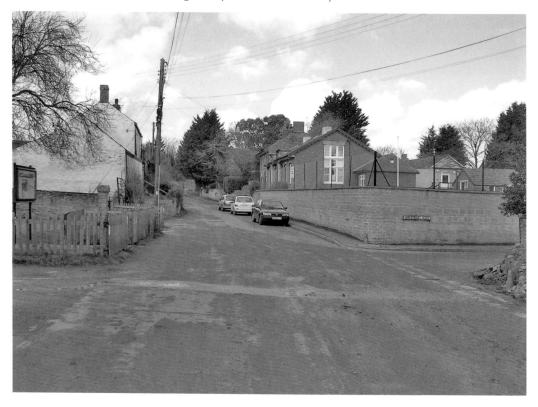

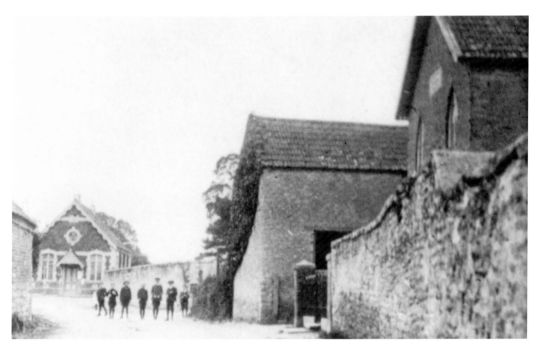

Middlezoy, Chapel Road, c. 1905

Children stand in the road just beyond the old chapel. The Wesleyan Methodist church or chapel of 1898 is the brick building just beyond them. The large building next to the school has gone, and the playground wall looks a little different.

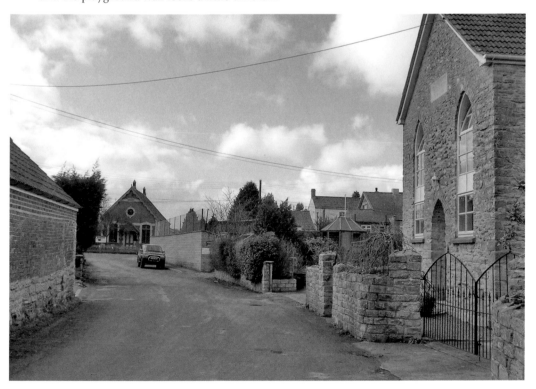

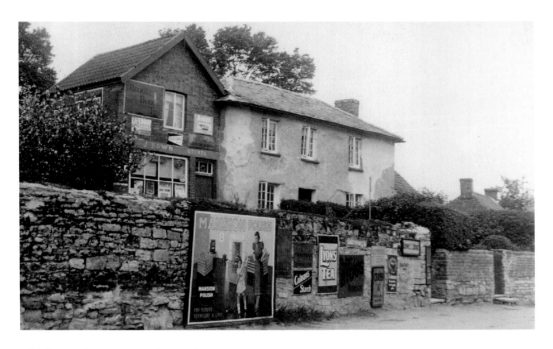

Middlezoy, the Stores, Main Road, *c.* 1920
For many years this was the village shop run by James and Annie Bown. James Bown also cut hair and removed teeth for people who could not afford a dentist. The old house and shop was demolished in the 1960s and three modern bungalows were built there. The next house along, Coronation Cottage, is still there today, the white house in the distance.

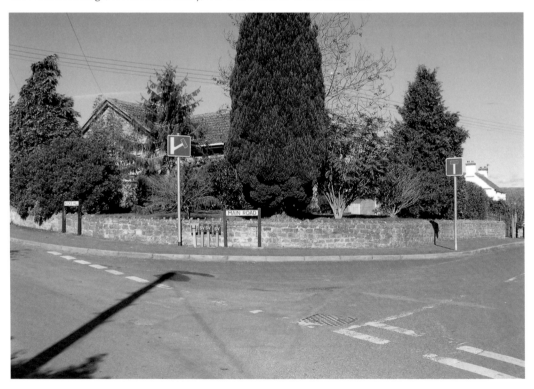

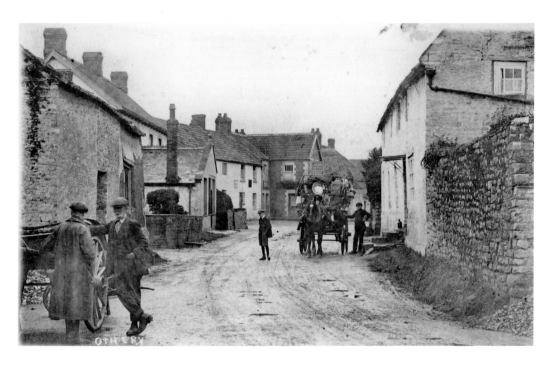

Othery, the London Hotel, c. 1905

The old London Hotel has become the London Inn today. In the old view a horse and cart stands in the street loaded with all manner of goods, perhaps a travelling salesman, or perhaps someone moving house. The post office building seems to have lost its tall chimney but it is still there today.

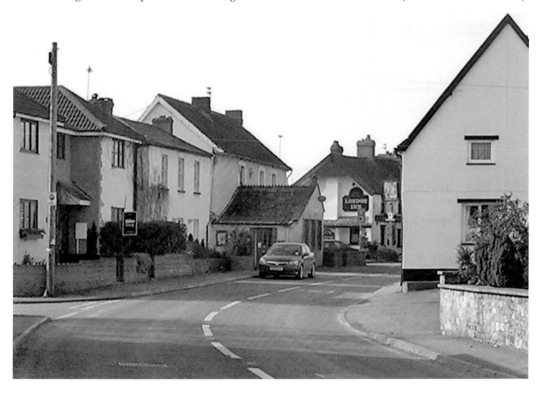

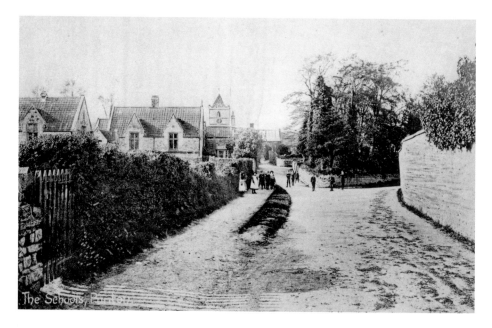

Puriton, the School, *c.* 1905

Many of the schoolchildren stand in the road in this view looking towards the church with the school building on the left. The church tower cannot now be seen due to modern tree growth, and the old school buildings are obscured by a white building. The high wall on the right and the walls around the triangle seem to be still there today. The triangle, now cleared of trees, is a nicely grassed area with a bench.

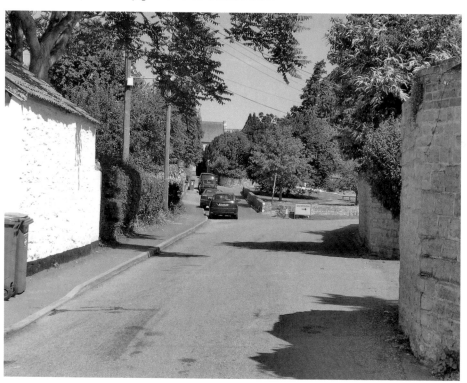

94

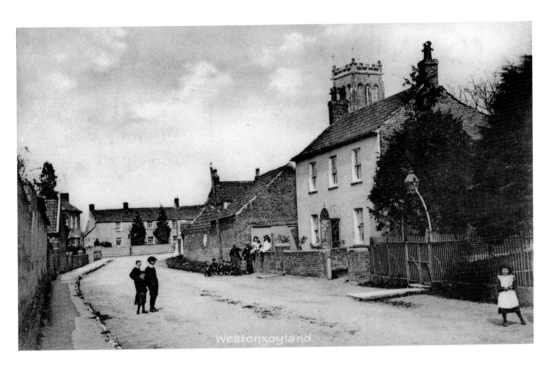

Westonzoyland, Main Road, 1912

The post office and the Sedgemoor Inn are just out of view at the end of the road in the distance. The old Methodist chapel is on the right-hand side and its railings are still there today. The wall on the left is no longer there due to houses being built along that side of the road. The post office was shut a few years ago.

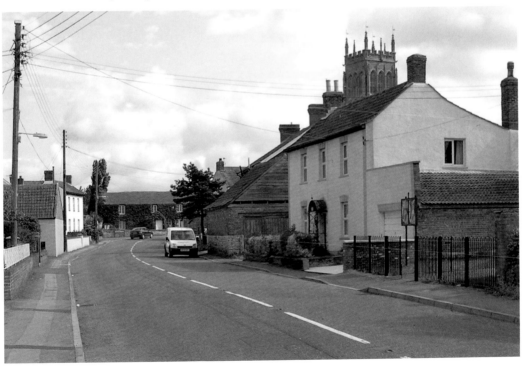

Acknowledgements

Most of the images in this book are from very old postcards, from the author's collection, on which the photographer or publisher's name was not printed. There are also a small number of old photographs, acquired over the years, which came with no history of who the photographer was. However, this book would not have been possible without their efforts, so it is only right that we should acknowledge their efforts, whosoever they were. They probably never envisaged their photographs being appreciated in this way, but appreciate them we do.

My grandfather, James Bown (1874–1966), took the 1920s Middlezoy photograph of 'The Stores'. Only this faded print of it survives.

The Bridgwater aerial photograph was taken by my late father, Mr Walter C. Bown (1920–2008), on the occasion of his eightieth birthday, during a light aircraft flight from Dunkerswell airfield in the year 2000.

I am also grateful to Anne Layton for three images that came from the photographic collection of Albert Rouault, her grandfather. They were:

Bridgwater, a Margarine Queue, 1914–18
Bridgwater, National Bus in St John's Street, 1920s
Cannington Bus, Early 1920s